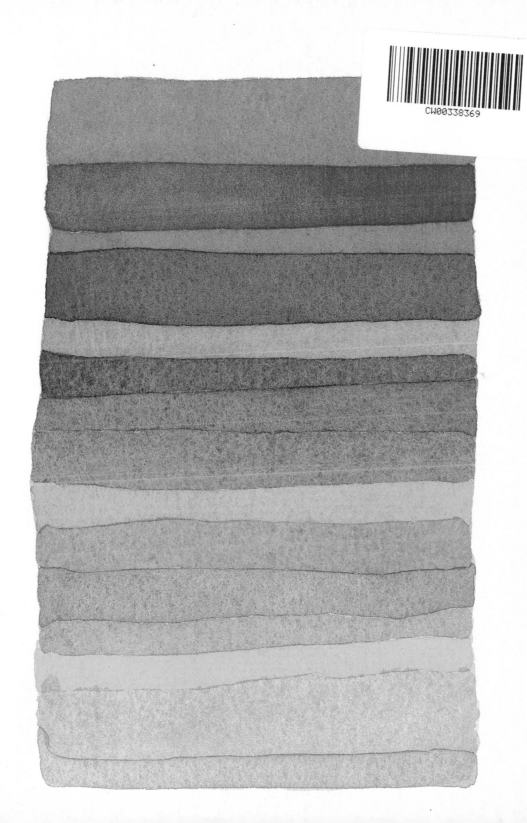

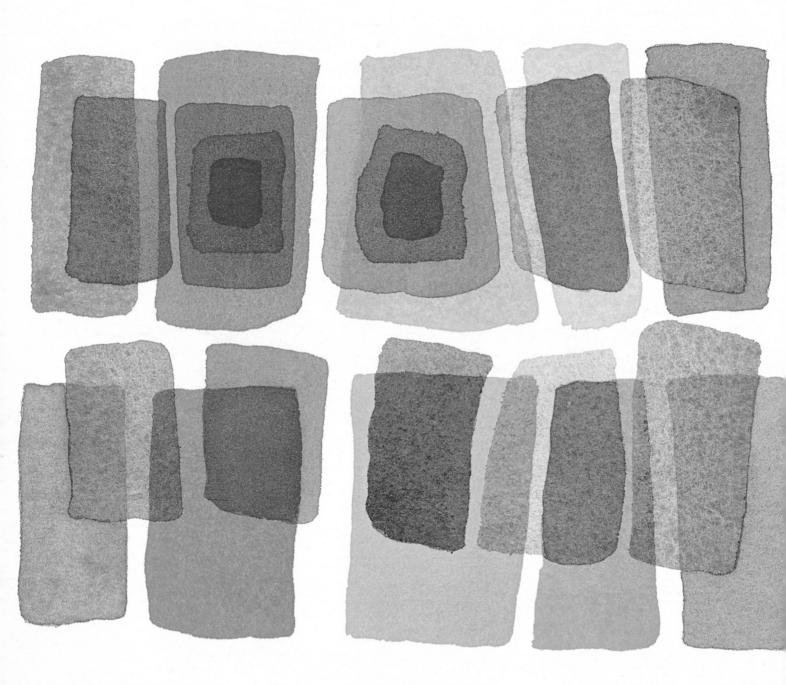

水彩画パターン ・ 水彩樣式

AQUARELLMUSTER • MOTIFS D'AQUARELLE

WATERCOLOUR PATTERNS

MOTIVOS CON ACUARELAS • PADRÕES COM AGUARELAS

MOTIVI DI ACQUERELLI

Joost van Roojen

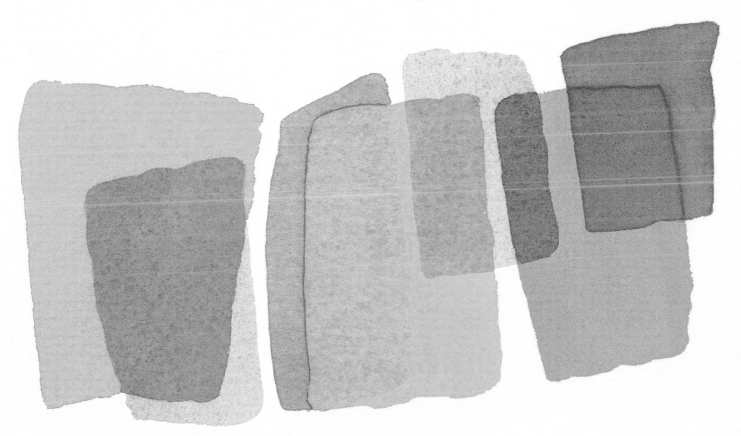

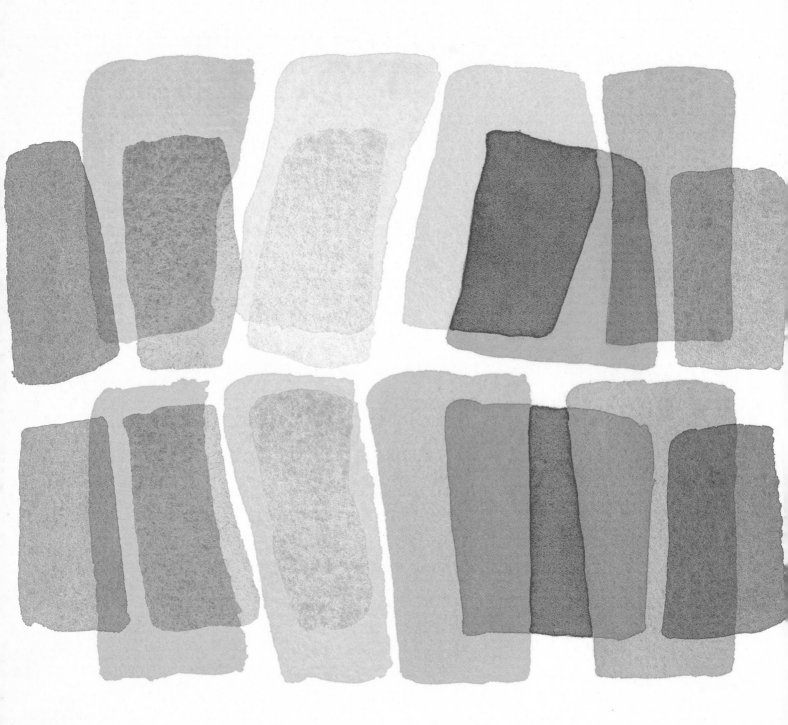

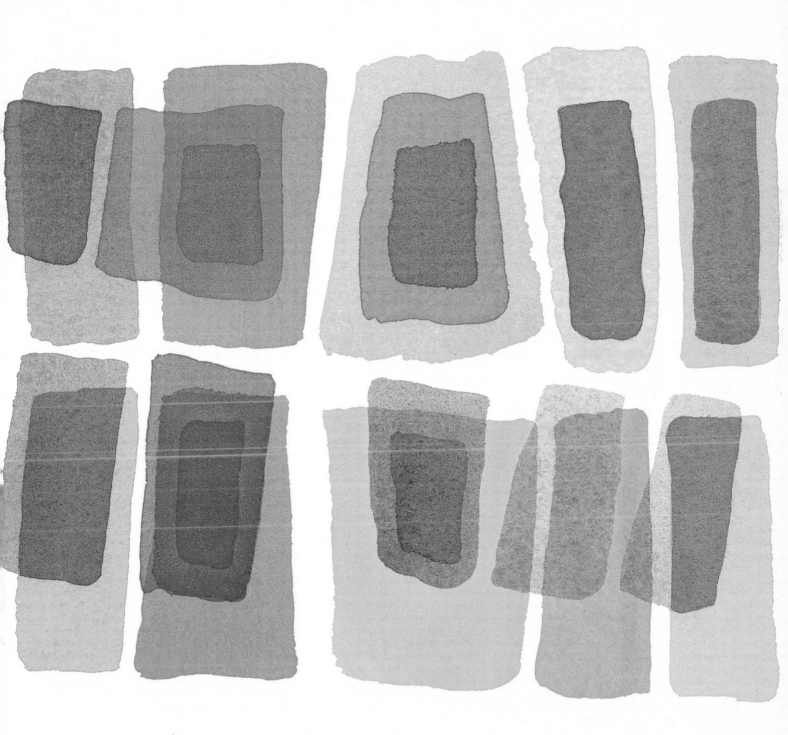

COLOPHON

Copyright © 2005 Pepin van Roojen
All rights reserved.

The Pepin Press | Agile Rabbit Editions
P.O. Box 10349
1001 EH Amsterdam, The Netherlands

Tel +31 20 420 20 21
Fax +31 20 420 11 52
mail@pepinpress.com
www.pepinpress.com

ISBN 90 5768 076 9

10 9 8 7 6 5 4 3 2 1
2010 09 08 07 06 05

Manufactured in Singapore

Watercolours by Joost van Roojen

Book design by Pepin van Roojen

Introduction by Pepin van Roojen
& Henk Jager

Translations: LocTeam, Barcelona (Spanish,
Italian, French, Portuguese and German) and
TheBigWord, Leeds (Japanese and Chinese)

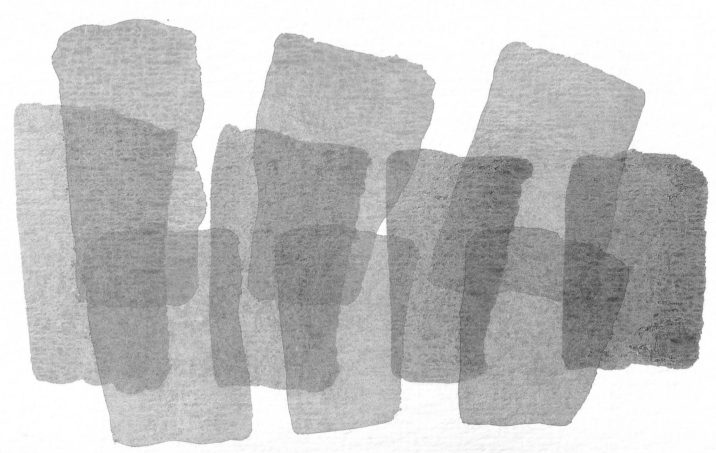

CONTENTS

Free CD-Rom in the inside back cover

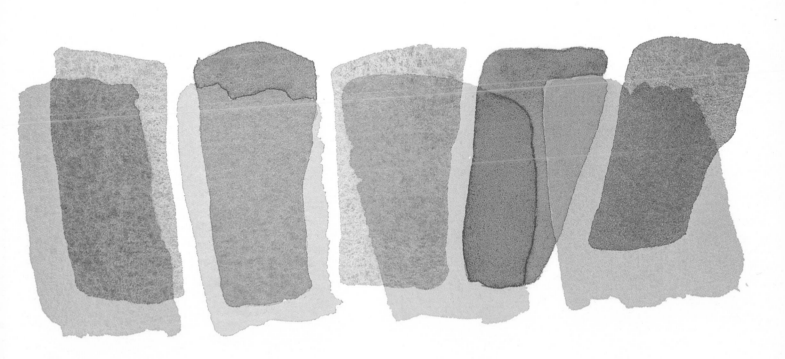

THE PEPIN PRESS | AGILE RABBIT EDITIONS

Graphic Themes & Pictures

90 5768 001 7	1000 Decorated Initials
90 5768 003 3	Graphic Frames
90 5768 007 6	Images of the Human Body
90 5768 012 2	Geometric Patterns
90 5768 014 9	Menu Designs
90 5768 017 3	Classical Border Designs
90 5768 055 6	Signs & Symbols
90 5768 024 6	Bacteria And Other Micro Organisms
90 5768 023 8	Occult Images
90 5768 046 7	Erotic Images & Alphabets
90 5768 062 9	Fancy Alphabets
90 5768 056 4	Mini Icons
90 5768 016 5	Graphic Ornaments
90 5768 025 4	Compendium of Illustrations
90 5768 021 1	5000 Animals (4 CDs)
90 5768 065 3	Teknological

Styles (Historical)

90 5768 089 0	Early Christian Patterns
90 5768 090 4	Byzanthine
90 5768 091 2	Romanesque
90 5768 092 0	Gothic
90 5768 027 0	Mediæval Patterns
90 5768 034 3	Renaissance
90 5768 033 5	Baroque
90 5768 043 2	Rococo
90 5768 032 7	Patterns of the 19th Century
90 5768 013 0	Art Nouveau Designs
90 5768 060 2	Fancy Designs 1920
90 5768 059 9	Patterns of the 1930s
90 5768 072 6	Art Deco Designs

Styles (Cultural)

90 5768 006 8	Chinese Patterns
90 5768 009 2	Indian Textile Prints
90 5768 011 4	Ancient Mexican Designs
90 5768 020 3	Japanese Patterns
90 5768 022 x	Traditional Dutch Tile Designs
90 5768 028 9	Islamic Designs
90 5768 029 7	Persian Designs
90 5768 036 X	Turkish Designs
90 5768 042 4	Elements of Chinese & Japanese Design
90 5768 071 8	Arabian Geometric Patterns

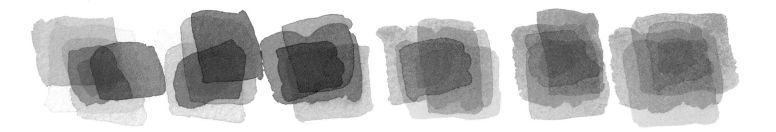

Textile Patterns

Photographs

Folding & Packaging

Web Design

Miscellaneous

More titles in preparation. In addition to the Agile Rabbit series of book +CD-ROM sets, The Pepin Press publishes a wide range of books on art, design, architecture, applied art, and popular culture.

Please visit www.pepinpress.com for more information.

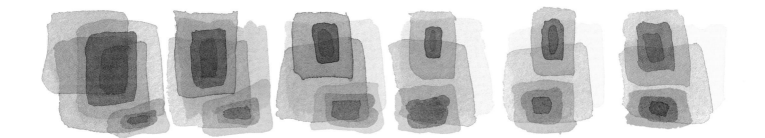

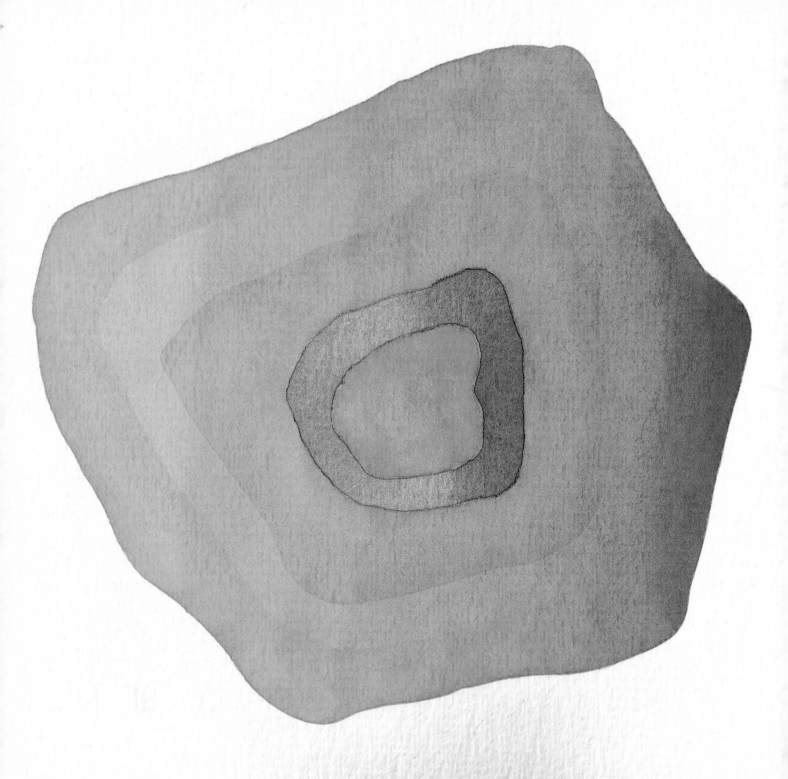

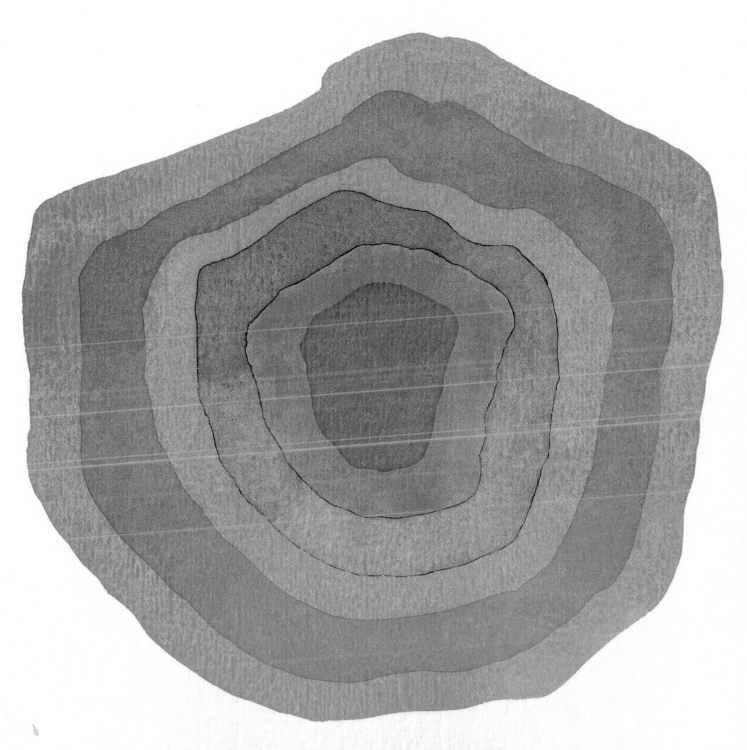

Joost van Roojen

Joost van Roojen (1928) started painting during the Second World War and has been working as an independent artist ever since.

Since 1958 he has also been working as a designer and creator of art projects in large buildings and public spaces. He has completed some 60 major projects with architects such as Van Den Broek & Bakema (including the murals in the auditorium of the Technical University, Delft 1965), Gawronski (Dutch Embassy, Jakarta, 1979 and others) and Hertzberger (Utrecht Music Theatre, 1979; Ministry of Social Affairs, The Hague, 1990). In conjunction with Aldo van Eyck, he won the prestigious 'Sikkens Prize' for his mural on a children's playground in Amsterdam.

Independent Work

In his younger years, Van Roojen also worked with oil paint. However, in his independent work he has concentrated on watercolour since the 1950s. He has gained fabulous technical mastery of this medium, and his ability to paint large, transparent, fading surfaces is unique.

Van Roojen's work is hard to typify and impossible to classify. As a fiercely independent soul, he never sought to join any artistic group; rather the contrary. Long journeys through the Sahara in 1950 and 1970 made a great impression on him and influenced his sense of space and light. He works largely on intuition, and his paintings often evolve in series of ten or more.

Van Roojen's work has been exhibited in several European countries, most recently in the Stedelijk Museum, Amsterdam in 2002.

Book and CD-ROM

The watercolour patterns in this book were specially painted by Joost van Roojen for use by artists and designers. All the illustrations are stored on the enclosed free CD-ROM and are ready to use for professional quality printed media and web page design.

The pictures can also be used to produce postcards, either on paper or digitally, or to decorate your letters, flyers, etc. They can be imported directly from the CD into most design, image-manipulation, illustration, word-processing and e-mail programs. Some programs will allow you to access the

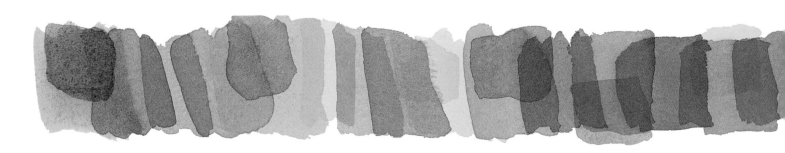

images directly; in others, you will first have to create a document, and then import the images. Please consult your software manual for instructions.

The names of the files on the CD-ROM correspond with the page numbers in this book. The CD-ROM comes free with this book, but is not for sale separately. The publishers do not accept any responsibility should the CD not be compatible with your system.

For non-professional applications, single images can be used free of charge. The images cannot be used for any type of commercial or otherwise professional application – including all types of printed or digital publications – without prior permission from The Pepin Press / Agile Rabbit Editions.

The files on the CD-ROM are high quality and sufficiently large for most applications. When needed, larger files can be ordered from The Pepin Press / Agile Rabbit editions.

For inquiries about permissions and fees, please contact:
mail@pepinpress.com
Fax +31 20 4201152

The Pepin Press / Agile Rabbit Editions

The Pepin Press / Agile Rabbit Editions book and CD-ROM sets offer a wealth of visual information and ready-to-use material for creative people. We publish various series as part of this line: graphic themes and pictures, photographs, packaging, web design, textile patterns, styles as defined by culture and the historical epochs that have generated a distinctive ornamental style. A list of available and forthcoming titles can be found at the beginning of this book. Many more volumes are being readied for publication, so we suggest you check our website from time to time for new additions.

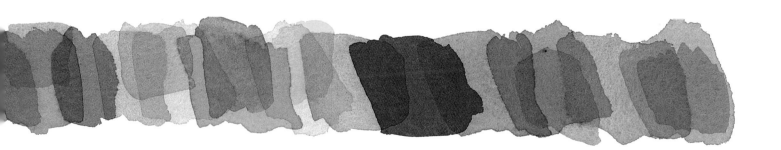

Joost van Roojen

Joost van Roojen (1928) a commencé à peindre pendant la Deuxième Guerre mondiale et travaille depuis comme artiste indépendant.

Depuis 1958, il travaille également en tant que dessinateur et créateur de projets artistiques pour de grands bâtiments et des espaces publics. Il a réalisé une soixantaine de projets d'envergure avec des architectes comme Van Den Broek & Bakema (notamment les peintures murales de l'auditorium de l'Université Technique de Delft en 1965), Gawronski (l'Ambassade de Hollande à Jakarta en 1979 par exemple) et Hertzberger (le Théâtre de la Musique d'Utrecht en 1979,le Ministère des Affaires Sociales à La Hague en 1990). Conjointement avec Aldo van Eyck, il a gagné le prestigieux « Sikkens Prize » pour une peinture murale réalisée dans une cour de récréation à Amsterdam.

Un travail indépendant

Durant ses jeunes années, Van Roojen a également travaillé avec la peinture à l'huile. Mais depuis les années 50, il se concentre sur l'aquarelle dans son travail indépendant. Il a acquis une fabuleuse maîtrise technique de cette discipline et son talent pour peindre des surfaces transparentes et délavées de grande taille est exceptionnel.

L'œuvre de Van Roojen est inclassable et difficile à caractériser. Farouchement indépendant, il n'a jamais cherché à se joindre à un groupe artistique, bien au contraire. De longs voyages à travers le Sahara en 1950 et en 1970 l'ont profondément marqué et ont influencé son sens de l'espace et de la lumière. Il travaille beaucoup à l'intuition et ses tableaux évoluent souvent en séries de dix ou plus. L'œuvre de Van Roojen a été exposée dans plusieurs pays européens et récemment au Musée Stedelijk d'Amsterdam en 2002.

Livre et CD-ROM

Les modèles d'aquarelle de cet ouvrage ont été peints par Joost van Roojen tout spécialement à l'intention des artistes et dessinateurs. Toutes les images sont stockées sur le CD-ROM et permettent la réalisation d'impressions de qualité professionnelle et la création de pages web. Elles permettent également de créer des cartes postales, aussi bien sur papier que virtuelles, ou d'agrémenter vos courriers, prospectus et autres.

Vous pouvez les importer directement à partir du CD dans la plupart des applications de création, manipulation graphique, illustration, traitement de texte et messagerie. Certaines applications permettent d'accéder directement aux images, tandis qu'avec d'autres, vous devrez d'abord créer

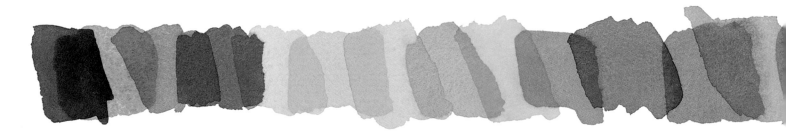

un document, puis y importer les images. Veuillez consulter les instructions dans le manuel du logiciel concerné.

Sur le CD, les noms des fichiers correspondent aux numéros de pages du livre.

Le CD-ROM est fourni gratuitement avec le livre et ne peut être vendu séparément. L'éditeur décline toute responsabilité si ce CD n'est pas compatible avec votre ordinateur. Vous pouvez utiliser les images individuelles gratuitement avec des applications non-professionnelles. Il est interdit d'utiliser les images avec des applications de type professionnel ou commercial (y compris avec tout type de publication numérique ou imprimée) sans l'autorisation préalable des éditions Pepin Press / Agile Rabbit.

Les fichiers figurant sur le CD-ROM sont de qualité supérieure et de taille acceptable pour la plupart des applications. Les fichiers plus volumineux ou vectorisés sont disponibles pour la plupart des images et peuvent être commandés auprès des éditions Pepin Press / Agile Rabbit.

Adresse électronique et numéro de télécopie à utiliser pour tout renseignement relatif aux autorisations et aux frais d'utilisation :
mail@pepinpress.com
Télécopie : +31 20 4201152

Éditions Pepin Press / Agile Rabbit

Les coffrets Livre + CD-ROM des éditions Pepin Press / Agile Rabbit proposent aux esprits créatifs une mine d'informations visuelles et de documents prêts à l'emploi. Dans le cadre de cette collection, nous publions plusieurs séries : thèmes et images graphiques, photographies, packaging, création de sites web, motifs textiles, styles tels qu'ils sont définis par chaque cultureet époques de l'histoire ayant engendré un style ornemental caractéristique. Vous trouverez une liste des titres disponibles et à venir au début de cet ouvrage. De nombreux autres volumes étant en cours de préparation, nous vous suggérons de consulter notre site web de temps à autre pour prendre connaissance des nouveautés.

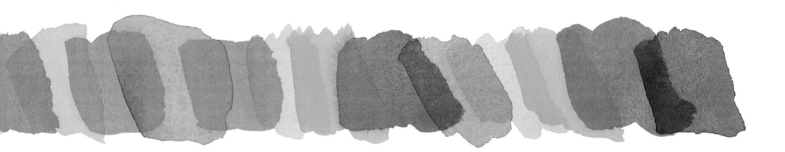

Joost van Roojen

Joost van Roojen (1928) begann während des zweiten Weltkriegs mit der Malerei und arbeitet seither als freischaffender Künstler.

Seit 1958 wirkt er darüber hinaus auch als Designer und Kunstschaffender für Kunstprojekte in großen Gebäuden und öffentlichen Räumen. Er vollendete rund 60 große Projekte mit Architekten wie Van Den Broek & Bakema (darunter die Wandmalereien im Auditorium der Technischen Universität Delft, 1965), Gawronski (Niederländische Botschaft, Jakarta, 1979 und andere) und Hertzberger (Musiktheater Utrecht, 1979; Ministerium für Soziales, Den Haag, 1990). Gemeinsam mit Aldo van Eyck wurde er für seine Wandmalerei auf einem Kinderspielplatz in Amsterdam mit dem renommierten Sikkens-Prize ausgezeichnet.

Freischaffende Tätigkeit

In seinen früheren Jahren arbeitete Van Roojen auch mit Ölfarben. Doch als freischaffender Künstler konzentriert er sich seit den fünfziger Jahren vorrangig auf Aquarellfarben. Er beherrscht diese Technik perfekt und malt große, transparente, verschwimmende Oberflächen wie kein anderer. Es ist nicht einfach, das Werk von Van Roojen zu charakterisieren oder zu klassifizieren. Der äußerst unabhängige Künstler versuchte niemals, einer künstlerischen Gruppe beizutreten – ganz im Gegenteil. Lange Reisen durch die Sahara in den Jahren 1950 und 1970 beeindruckten ihn zutiefst und hatten einen nachhaltigen Einfluss auf sein Gefühl für Raum und Licht. Er arbeitet vorwiegend intuitiv, und seine Gemälde entstehen oft in Serien von zehn oder mehr Stück.

Die Werke von Van Roojen werden in verschiedenen europäischen Ländern ausgestellt, zuletzt im Jahr 2002 im Stedelijk Museum von Amsterdam.

Buch und CD-ROM

Die Aquarelldesigns in diesem Buch wurden von Joost van Roojen eigens zur Verwendung von Künstlern und Designern entworfen. Alle Abbildungen sind in hoher Auflösung auf der beiliegenden Gratis-CD-ROM gespeichert und lassen sich direkt zum Drucken in professioneller Qualität oder zur Gestaltung von Websites einsetzen.

Sie können sie auch als Motive für Postkarten auf Karton oder in digitaler Form, oder als Ausschmückung für Ihre Briefe, Flyer etc. verwenden. Die Bilder lassen sich direkt in die meisten Zeichen-, Bildbearbeitungs-, Illustrations-, Textverarbeitungs- und E-Mail-Programme laden, ohne

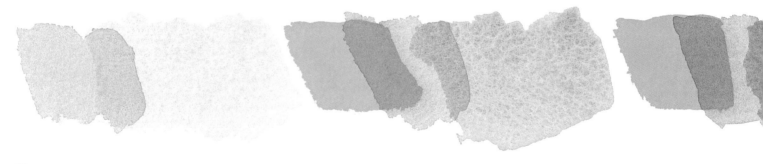

dass zusätzliche Programme installiert werden müssen. In einigen Programmen können die Dokumente direkt geladen werden, in anderen müssen Sie zuerst ein Dokument anlegen und können dann die Datei importieren. Genauere Hinweise dazu finden Sie im Handbuch zu Ihrer Software. Die Namen der Bilddateien auf der CD-ROM entsprechen den Seitenzahlen dieses Buchs. Die CD-ROM wird kostenlos mit dem Buch geliefert und ist nicht separat verkäuflich. Der Verlag haftet nicht für Inkompatibilität der CD-ROM mit Ihrem System.

Für nicht professionelle Anwendungen können einzelne Bilder kostenfrei genutzt werden. Die Bilder dürfen ohne vorherige Genehmigung von The Pepin Press / Agile Rabbit Editions nicht für gewerbliche oder anderweitige professionelle Anwendungen einschließlich aller Arten von gedruckten oder digitalen Medien eingesetzt werden.

Die Dateien auf der CD-ROM sind in Bezug auf Qualität und Größe für die meisten Verwendungszwecke geeignet. Bei Bedarf können größere Dateien bei The Pepin Press / Agile Rabbit Editions angefordert werden.

Für Fragen zu Genehmigungen und Preisen wenden Sie sich bitte an:
mail@pepinpress.com
Fax +31 20 4201152

The Pepin Press / Agile Rabbit Editions

Die aus Buch und CD-ROM bestehenden Sets von The Pepin Press / Agile Rabbit Editions bieten eine Fülle an visuellen Informationen und sofort verwendbarem Material für kreative Menschen. Im Rahmen dieser Reihe veröffentlichen wir verschiedene Serien: grafische Themen und Bilder, Fotos, Aufmachungen, Webdesigns, Stoffmuster sowie von Kulturströmungen und geschichtlichen Epochen geprägte Stilrichtungen, die eine eigene dekorative Stilrichtung hervorgebracht haben. Eine Liste der verfügbaren und kommenden Titel finden Sie am Anfang dieses Buchs. Viele weitere Bände befinden sich gerade in Vorbereitung – besuchen Sie daher regelmäßig unsere Website, um sich über Neuerscheinungen zu informieren.

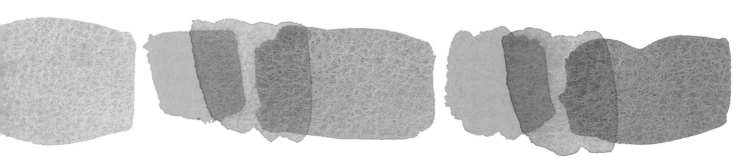

Joost van Roojen

Joost van Roojen (1928) começou a pintar durante a Segunda Guerra Mundial e tem trabalhado como artista independente desde então.

Desde 1958, também trabalha como designer e criador de projectos artísticos para grandes edifícios e espaços públicos. Já realizou cerca de 60 projectos de grande envergadura com arquitectos como Van Den Broek & Bakema (incluindo os murais do auditório da Universidade Técnica de Delft, 1965), Gawronski (Embaixada dos Países Baixos em Jacarta, 1979, entre outros) e Hertzberger (Teatro da Música de Utreque, 1979; Ministério dos Assuntos Sociais, em Haia, 1990). Em colaboração com Aldo van Eyck, ganhou o prestigiado «Prémio Sikkens» pelo mural que criou num parque infantil de Amsterdão.

Trabalho Independente

Na juventude, Van Roojen também trabalhou com pintura a óleo. Todavia, desde a década de 1950, o seu trabalho como independente concentrou-se na aguarela, tendo adquirido uma mestria fabulosa desta técnica. A sua capacidade de pintar grandes superfícies, transparentes e esmorecidas, é única. É difícil tipificar a obra de Van Roojen, e classificá-la é simplesmente impossível. A postura independente que sempre cultivou fez com que nunca procurasse integrar-se em nenhum grupo artístico, antes pelo contrário. As longas viagens pelo Sara em 1950 e 1970 deixaram nele marcas profundas e influenciaram a sua noção de espaço e luz. A intuição é uma marca indelével da sua obra, não sendo invulgar que as suas pinturas evoluam em séries de dez ou mais.

A obra de Van Roojen já foi objecto de exposições em vários países europeus, tendo a mais recente sido no Stedelijk Museum de Amsterdão, em 2002.

Livro e CD-ROM

Os padrões de aguarela deste livro foram especialmente pintados por Joost van Roojen para serem utilizados por artistas e designers. Todas as ilustrações estão armazenadas no CD-ROM gratuito que acompanha o livro e estão prontas para serem utilizadas em materiais impressos de qualidade profissional e na concepção de páginas para a Web.

As imagens podem, também, ser utilizadas para criar postais, em papel ou digitais, ou para decorar cartas, panfletos, etc. Podem ser importadas directamente do CD para a maioria dos programas de desenho, manipulação de imagens, ilustração, processamento de texto e correio electrónico. Alguns

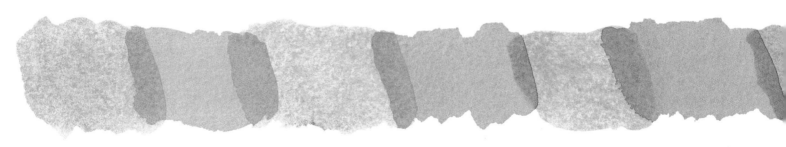

programas permitem o acesso directo às imagens, ao passo que noutros é necessário criar primeiro um documento para, em seguida, importar para ele as imagens. Consulte o manual do software para obter instruções.

Os nomes dos ficheiros no CD-ROM correspondem aos números das páginas do livro. O CD-ROM é fornecido gratuitamente com este livro, mas não pode ser vendido separadamente. Os editores não assumem qualquer responsabilidade em caso de incompatibilidade do CD com o sistema operativo do utilizador.

A utilização de imagens individuais para aplicações não profissionais é gratuita. As imagens não podem ser utilizadas para nenhum tipo de aplicação comercial ou profissional, incluindo todo e qualquer tipo de publicação impressa ou digital, sem a prévia autorização da The Pepin Press / Agile Rabbit Editions.

Os ficheiros no CD-ROM são de alta qualidade e suficientemente grandes para a maioria das aplicações. Se necessário, é possível encomendar ficheiros maiores à The Pepin Press / Agile Rabbit Editions.

Para obter esclarecimentos sobre autorizações e preços, contacte:
mail@pepinpress.com
Fax +31 20 4201152

The Pepin Press/Agile Rabbit Editions

Os conjuntos de livro e CD-ROM da The Pepin Press / Agile Rabbit Editions proporcionam uma grande variedade de informações visuais e disponibilizam materiais prontos a utilizar para pessoas criativas. Nesta linha, publicamos várias séries: temas gráficos e imagens, fotografias, embalagens, design para a Web, padrões têxteis, estilos culturais e épocas históricas que produziram estilos ornamentais característicos. Nas primeiras páginas deste livro, é apresentada uma lista de títulos já publicados e a sair. Muitos mais estão em preparação, pelo que sugerimos que consulte regularmente o nosso sítio na Web para ficar a par das novidades.

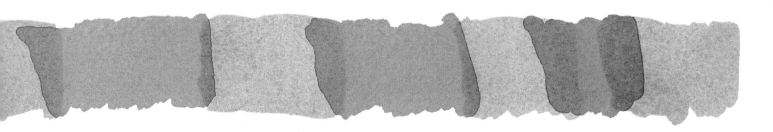

Joost van Roojen

Joost van Roojen (1928) inició su trayectoria pictórica durante la II Guerra Mundial y desde entonces se ha dedicado al arte de forma autónoma.

En 1958 empezó a combinar esta actividad con la de diseñador y creador de proyectos artísticos en grandes edificios y espacios públicos. Ha llevado a cabo unos 60 proyectos de gran envergadura en colaboración con arquitectos como Van Den Broek & Bakema (como los murales del auditorio de la Universidad Técnica de Delft, 1965), Gawronski (entre otros, la embajada neerlandesa de Yakarta, 1979) y Hertzberger (Teatro de la música de Utrecht, 1979; Ministerio de Asuntos Sociales, La Haya, 1990). Fue galardonado junto a Aldo van Eyck con el prestigioso Sikkens Prize, por un mural en un patio infantil de Ámsterdam.

Un artista independiente

Si bien en sus inicios Van Roojen también pintó al óleo, desde la década de 1950 se ha concentrado en la acuarela, técnica en la que es todo un maestro. Además, destaca por una habilidad única para pintar grandes superficies transparentes que parecen a punto de desvanecerse.

La obra de Van Roojen es difícil de tipificar e imposible de clasificar. Su carácter, ferozmente independiente, le ha llevado a evitar la vinculación con cualquier grupo artístico, más bien al contrario. Los prolongados viajes que realizó por el Sahara durante las décadas de los cincuenta y los setenta le impresionaron profundamente e influenciaron su concepto de la luz y el espacio. A la hora de trabajar, se basa en gran medida en la intuición y sus pinturas suelen evolucionar hasta conformar series de diez o más cuadros.

La obra de Van Roojen ha podido admirarse en diversos países europeos y el Stedelijk Museum de Ámsterdam albergó su última exposición en 2002.

Libro y CD Rom

Joost van Roojen pintó especialmente los patrones para acuarela de este libro para su uso por parte de artistas y diseñadores. Se adjunta un CD-ROM gratuito donde hallará todas las ilustraciones en un formato de alta resolución, con las que podrá conseguir una impresión de calidad profesional y diseñar páginas web.

Las imágenes pueden también emplearse para realizar postales, de papel o digitales, o para decorar cartas, folletos, etc. Se pueden importar desde el CD a la mayoría de programas de diseño, manipulación de imágenes, dibujo, tratamiento de textos y correo electrónico, sin necesidad de utilizar un

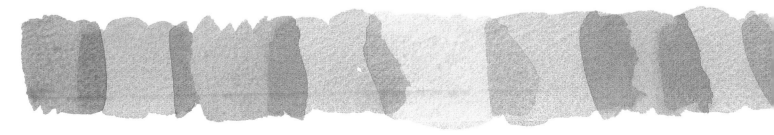

programa de instalación. Algunos programas le permitirán acceder a las imágenes directamente; otros, sin embargo, requieren la creación previa de un documento para importar las imágenes. Consulte su manual de software en caso de duda.

Los nombres de los archivos del CD-ROM se corresponden con los números de página de este libro. El CD-ROM se ofrece de manera gratuita con este libro, pero está prohibida su venta por separado. Los editores no asumen ninguna responsabilidad en el caso de que el CD no sea compatible con su sistema.

Se autoriza el uso de estas imágenes de manera gratuita para aplicaciones no profesionales. No se podrán emplear en aplicaciones de tipo profesional o comercial (incluido cualquier tipo de publicación impresa o digital) sin la autorización previa de The Pepin Press / Agile Rabbit Editions.

Los archivos incluidos en el CD-ROM son de gran calidad y su tamaño es adecuado para la mayor parte de las aplicaciones. No obstante, para la mayoría de las imágenes existen archivos de mayor tamaño, que pueden solicitarse a The Pepin Press / Agile Rabbit Editions.

Para más información acerca de autorizaciones y tarifas:

mail@pepinpress.com
Fax +31 20 4201152

The Pepin Press / Agile Rabbit Editions

Los libros con CD-ROM incluido que nos propone The Pepin Press / Agile Rabbit Editions ponen a disposición de los creativos una amplísima información visual y material listo para ser utilizado. Dentro de la colección Agile Rabbit se publican diferentes series: motivos gráficos e ilustraciones, fotografías, embalaje, diseño de páginas web, motivos textiles, y estilos definidos por una determinada cultura y por las épocas históricas que han generado un estilo ornamental distintivo. Al principio de este libro encontrará una lista de los títulos disponibles y en preparación. Estamos trabajando en muchos más volúmenes, por lo que le aconsejamos que visite periódicamente nuestra página web para estar informado de todas las novedades.

Joost van Roojen

Joost van Roojen (1928) iniziò la sua carriera artistica durante la Seconda Guerra Mondiale e da allora è sempre stato un pittore indipendente.
Dal 1958 lavora anche come designer e creatore d'oggetti d'arte per grandi edifici e spazi pubblici. Ha portato a termine una sessantina di progetti importanti in collaborazione con architetti del calibro di Van Den Broek & Bakema (tra cui i murales dell'auditorium del Politecnico di Delft, 1965), Gawronski (Ambasciata d'Olanda, Giacarta, 1979, e altri) e Hertzberger (Music Theatre di Utrecht, 1979; Ministero degli Affari Sociali, L'Aja, 1990). Insieme ad Aldo van Eyck, ha vinto il prestigioso 'Sikkens Prize' per i murales realizzati in un parco giochi per bambini ad Amsterdam.

Un artista indipendente
Nei primi anni della sua carriera, Van Roojen s'interessò anche di pittura a olio. Tuttavia, come artista indipendente si è concentrato fin dagli anni cinquanta sulla produzione di acquerelli. In questo campo è diventato un vero maestro e ha acquisito una fantastica e unica abilità nella pittura di grandi superfici evanescenti, trasparenti.
L'opera di Van Roojen sfugge a qualunque tentativo di tipizzazione e classificazione. Spirito fortemente indipendente, non ha mai cercato di unirsi a gruppi artistici, anzi se n'è sempre mantenuto a debita distanza. I lunghi viaggi compiuti nel Sahara nel 1950 e nel 1970 destarono in lui enorme impressione e hanno condizionato il suo senso dello spazio e della luce. La sua opera nasce fondamentalmente dall'intuizione e i suoi dipinti evolvono spesso in serie di dieci o più. Mostre delle opere di Van Roojen sono state allestite in diversi paesi europei, la più recente delle quali allo Stedelijk Museum di Amsterdam nel 2002.

Libro e CD-ROM
La serie di acquerelli cui è dedicato questo libro è stata realizzata da Joost van Roojen appositamente per essere utilizzata da artisti e designer. La maggior parte delle illustrazioni sono contenute nel CD-ROM gratuito allegato, in formato ad alta risoluzione e pronte per essere utilizzate per pubblicazioni professionali e pagine web.
Possono essere inoltre usate per creare cartoline, su carta o digitali, o per abbellire lettere, opuscoli, ecc. Dal CD, le immagini possono essere importate direttamente nella maggior parte dei programmi di grafica, di ritocco, di illustrazione, di scrittura e di posta elettronica; non è richiesto alcun tipo di

installazione. Alcuni programmi vi consentiranno di accedere alle immagini direttamente; in altri, invece, dovrete prima creare un documento e poi importare le immagini. Consultate il manuale del software per maggiori informazioni.

I nomi dei file del CD-ROM corrispondono ai numeri delle pagine del libro. Il CD-ROM è allegato gratuitamente al libro e non può essere venduto separatamente. L'editore non può essere ritenuto responsabile qualora il CD non fosse compatibile con il sistema posseduto.

Per le applicazioni non professionali, le singole immagini possono essere usate gratis. Per l'utilizzo delle immagini a scopo professionale o commerciale, comprese tutte le pubblicazioni digitali o stampate, è necessaria la relativa autorizzazione da parte della casa editrice The Pepin Press / Agile Rabbit Editions.

I file sul CD-ROM sono di alta qualità e sufficientemente grandi per poter essere usati nella maggior parte delle applicazioni. File di maggiori dimensioni possono essere richiesti e ordinati, se necessario, alla casa editrice The Pepin Press / Agile Rabbit Editions.

Per ulteriori informazioni rivolgetevi a:
mail@pepinpress.com
Fax +31 20 4201152

The Pepin Press / Agile Rabbit Editions

Il libro della Pepin Press / Agile Rabbit Editions e l'accluso CD-ROM mettono a disposizione dei creativi un ricco supporto visivo e materiale pronto per l'uso. La collana comprende diverse serie: motivi grafici e illustrazioni, fotografie, packaging, web design, motivi per tessuti, stili secondo la definizione data dalla cultura e dalle epoche storiche che hanno prodotto uno stile ornamentale particolare. Nelle prime pagine del libro è riportato l'elenco delle opere già in catalogo e di quelle in via di pubblicazione. Sono molti gli altri testi in via di pubblicazione, quindi consigliamo di visitare periodicamente il nostro sito internet per essere informati sulle novità.

日本語

本書にはグラフィック リソースやインスピレーションとして使用できる美しいイメージ画像が含まれています。すべてのイラストレーションは、無料の付属 CD-ROM（Mac および Windows 用）に高解像度で保存されており、これらを利用してプロ品質の印刷物や WEB ページを簡単に作成することができます。また、紙ベースまたはデジタルの葉書の作成やレター、ちらしの装飾等に使用することもできます。

これらの画像は、CD から主なデザイン、画像処理、イラスト、ワープロ、E メールソフトウェアに直接取り込むことができます。インストレーションは必要ありません。プログラムによっては、画像に直接アクセスできる場合や、一旦ドキュメントを作成した後に画像を取り込む場合等があります。詳細は、ご使用のソフトウェアのマニュアルをご参照下さい。

CD-ROM 上のファイル名は、本書のページ数に対応しています。ページに複数の画像が含まれる場合は、左から右、上から下の順番で番号がつけられ、ページ番号に続く数字または下記のレターコードで識別されます。

T = トップ（上部）、B = ボトム（下部）、C = センター（中央）、L = レフト（左）、R = ライト（右）

CD-ROM は本書の付属品であり、別売されておりません。CD がお客様のシステムと互換でなかった場合、発行者は責任を負わないことをご了承下さい。

プロ用以外のアプリケーションで、画像を一回のみ無料で使用することができます。The Pepin Press / Agile Rabbit Editions から事前許可を得ることなく、あらゆる形体の印刷物、デジタル出版物をはじめとする、あらゆる種類の商業用ならびにプロ用アプリケーションで画像を使用することを禁止します。

使用許可と料金については、下記までお問い合わせ下さい。

mail@pepinpress.com

ファックス： +31 20 4201152

中 文

本書包含精美圖片，可以作為圖片資源或激發靈感的資料使用。這些圖片存儲在所附的高清晰度免費 CD-ROM (可在 Mac 和 Windows 下使用) 中，可用於專業的高品質印刷媒體和網頁設計。圖片還可以用於製作紙質和數字明信片，或裝飾您的信封、傳單等。您無需安裝即可以把圖片直接從 CD 調入大多數的設計、圖像處理、圖片、文字處理和電子郵件程序。有些程序允許您直接使用圖片；另外一些，您則需要先創建一個文件，然後引入圖片。用法說明請參閱軟體說明書。

在 CD 中的文件名稱是與書中的頁碼相對應的。如果書頁中的圖片超過一幅，其順序為從左到右，從上到下。這會在書頁號後加一個數字來表示，或者是加一個字母：T = 上，B = 下，C = 中，L = 左，R = 右。

本書附帶的 CD-ROM 是免費的，但 CD-ROM 不單獨出售。如果 CD 與您的系統不相容，出版商不承擔任何責任。

就非專業的用途而言，可以免費使用單個圖片。若未事先得到 The Pepin Press/Agile Rabbit Editions 的許可，不得將圖片用於任何其他類型的商業或專業用途 - 包括所有類型的印刷或數字出版物。

有關許可及收費的詢問，請查詢：

Mail@pepinpress.com

傳真： +31 20 4201152

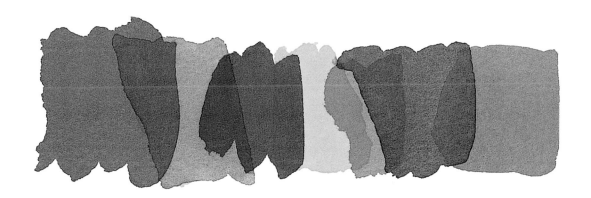

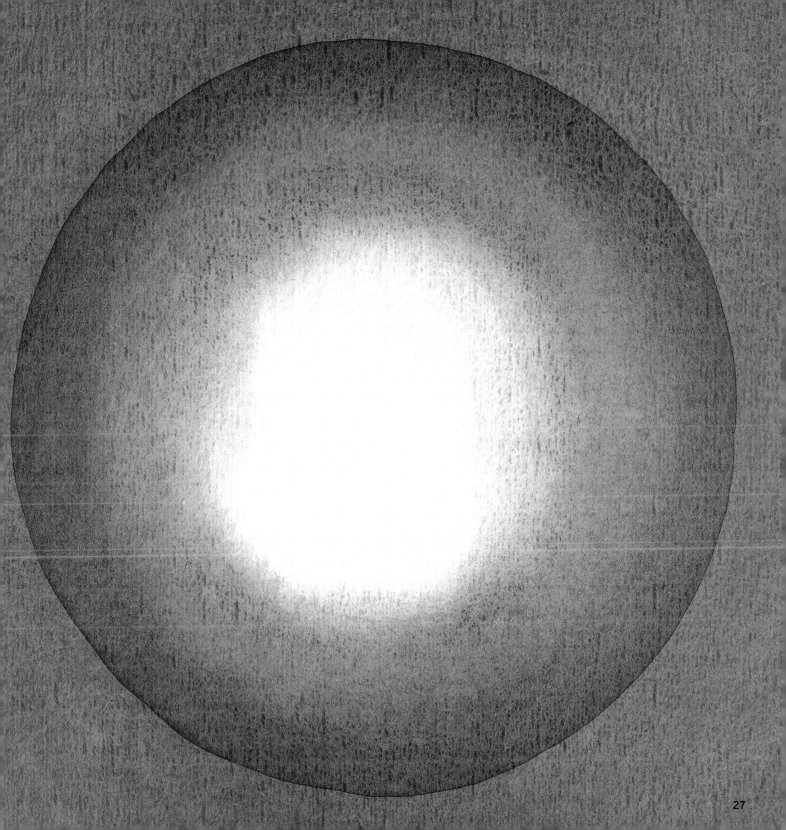

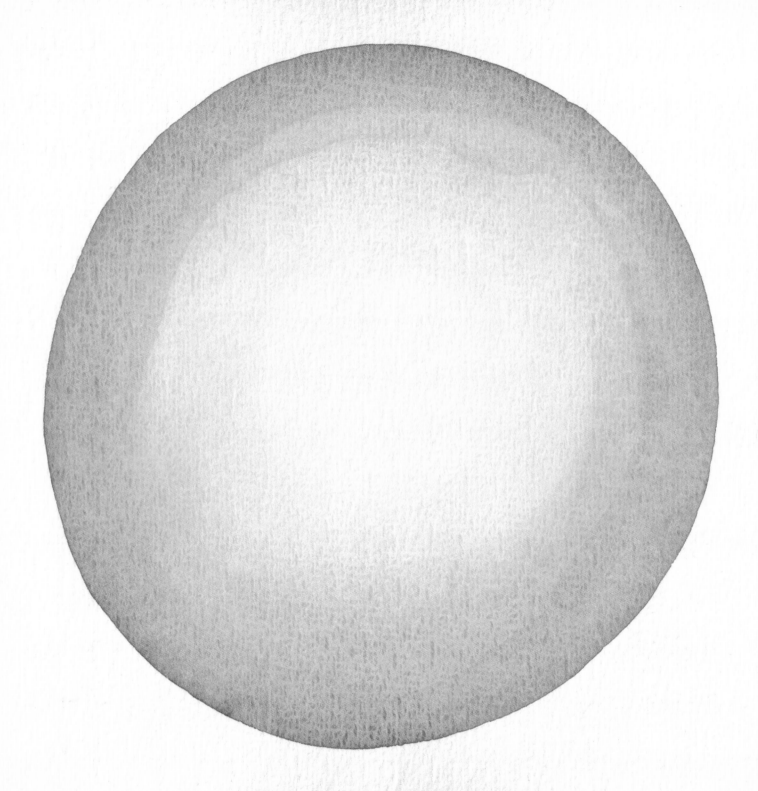

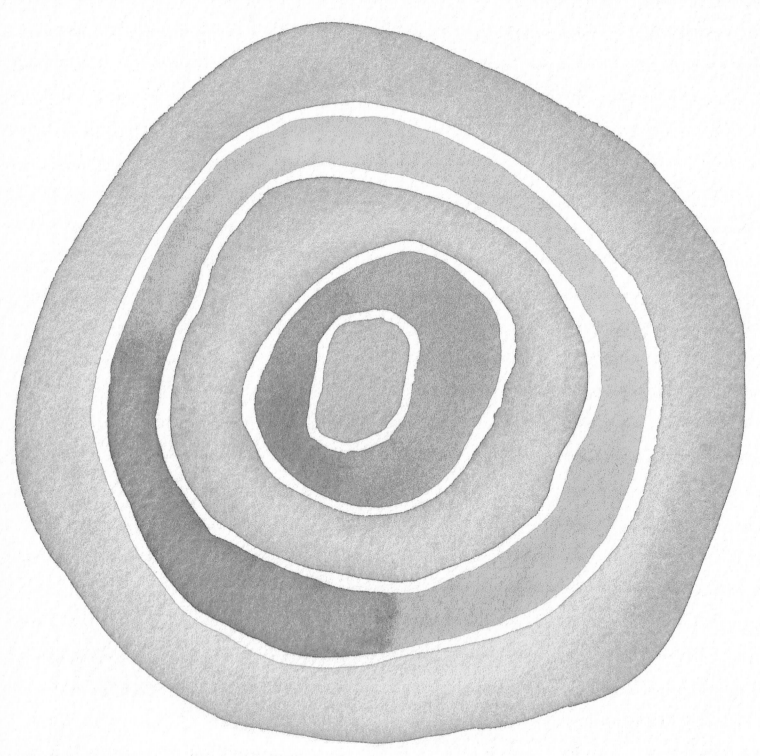

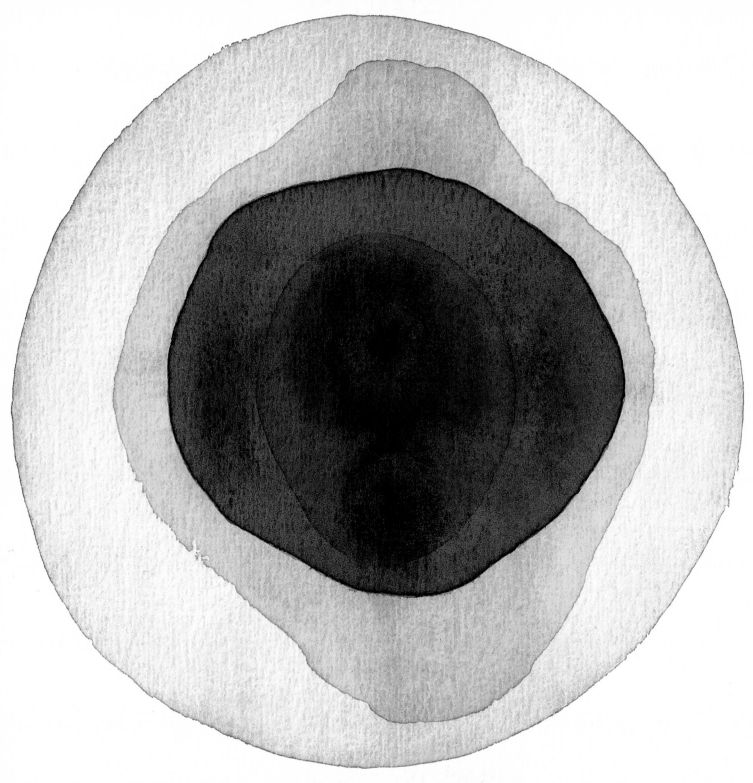

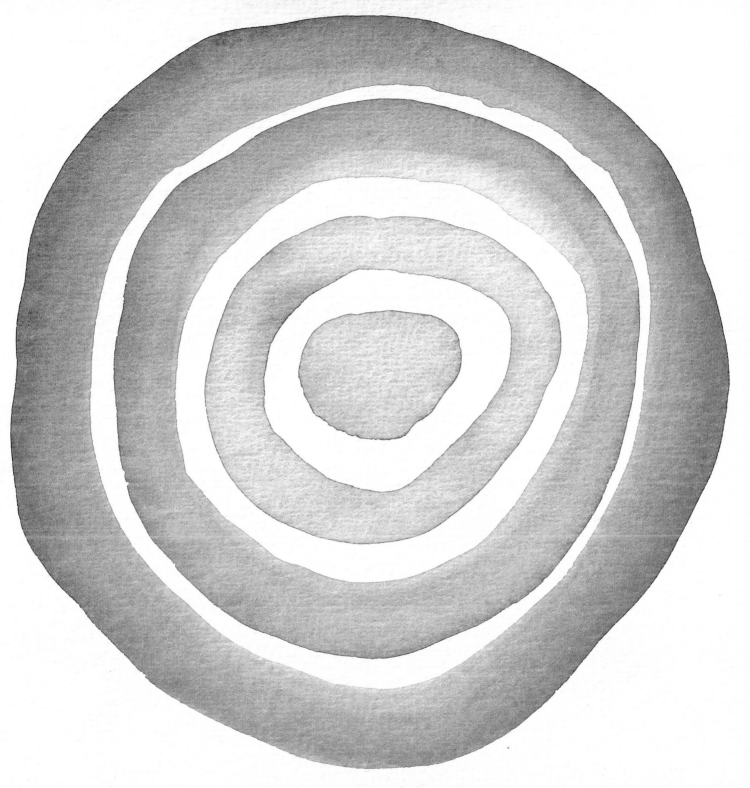

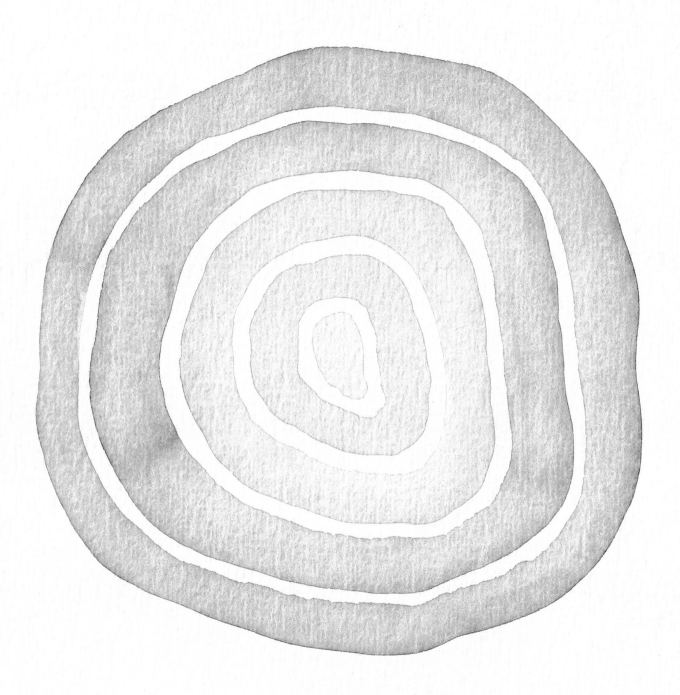

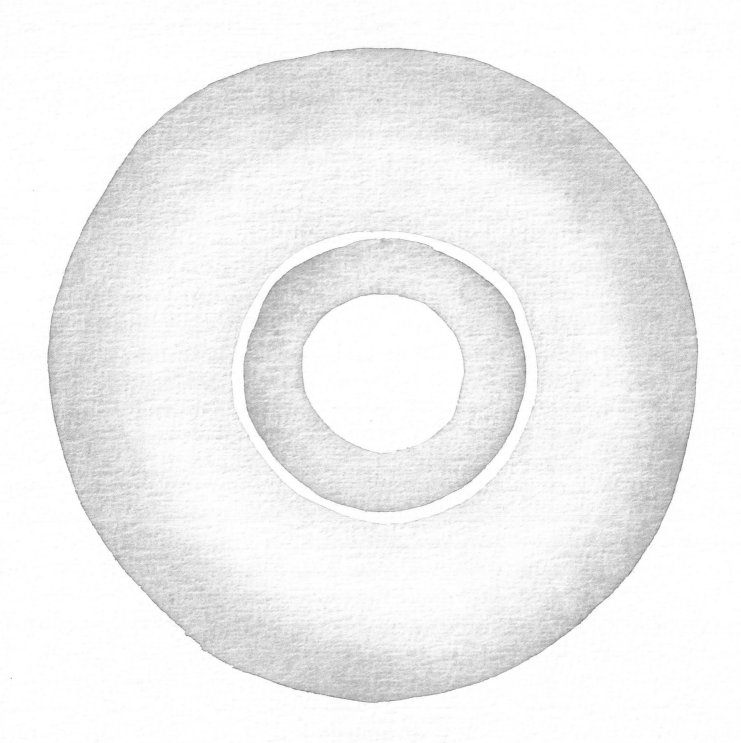

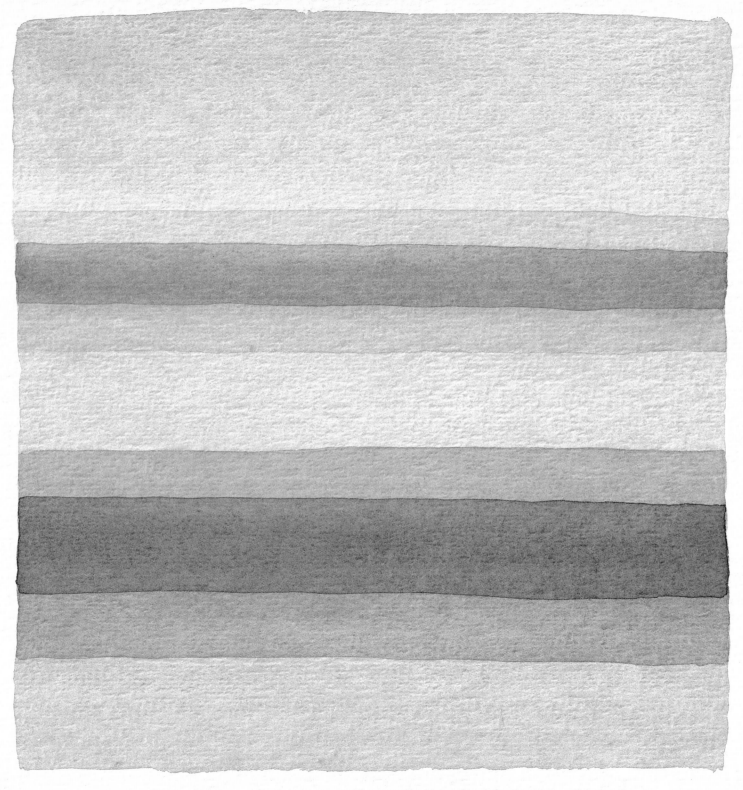

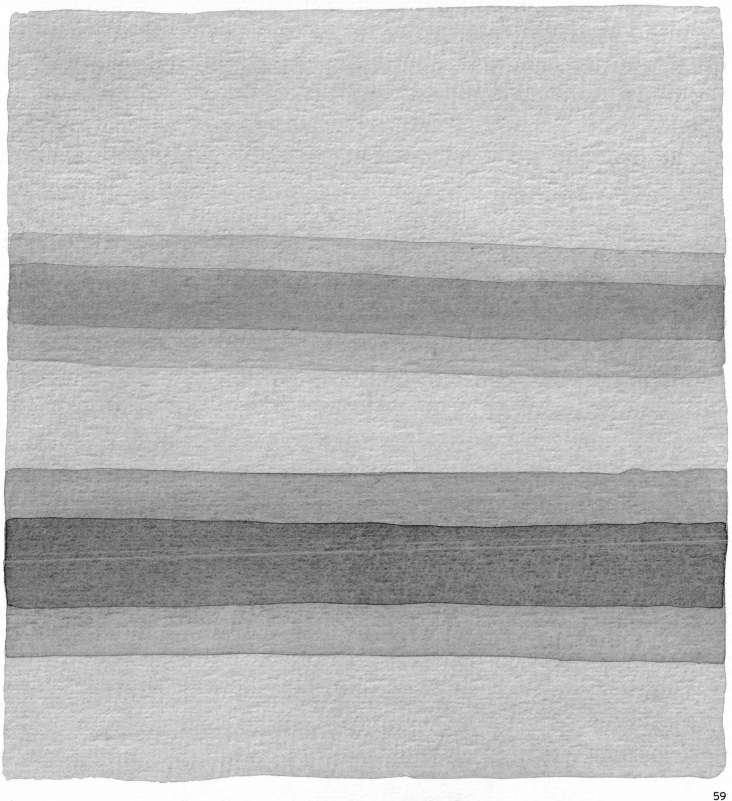

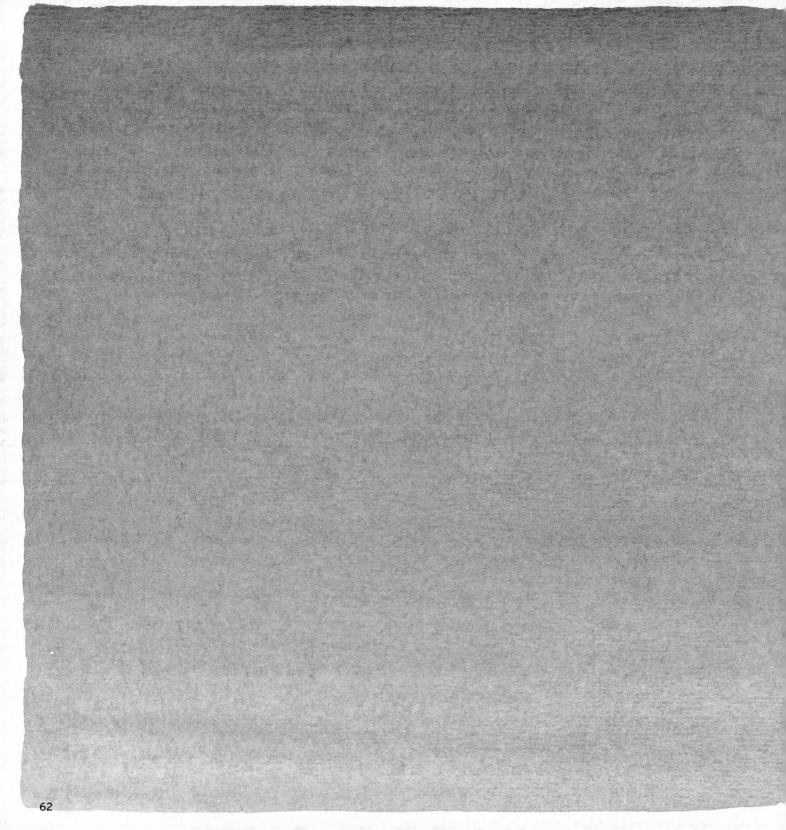

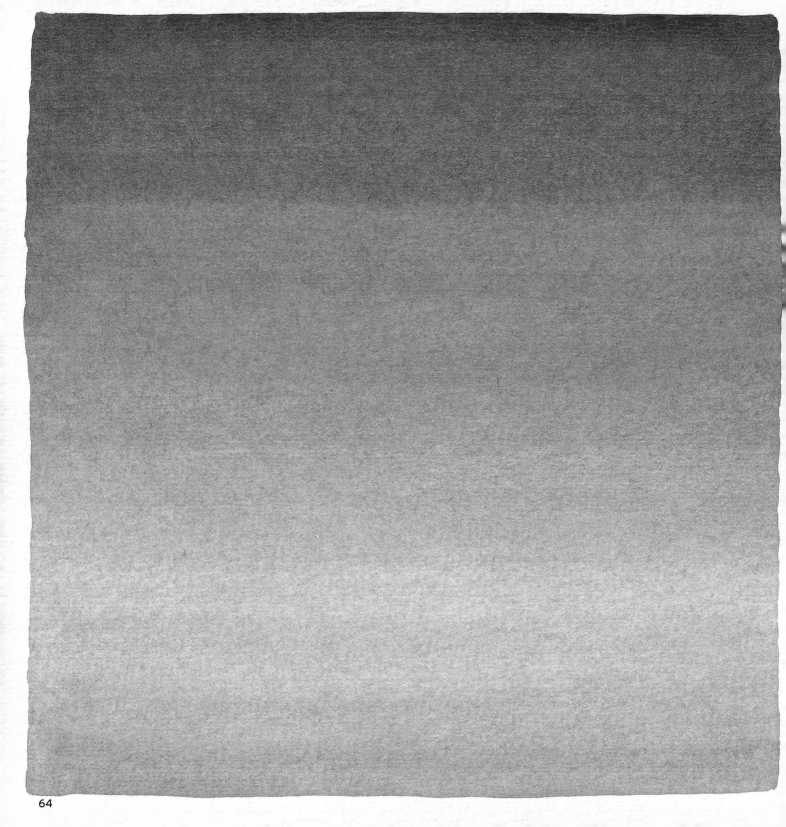

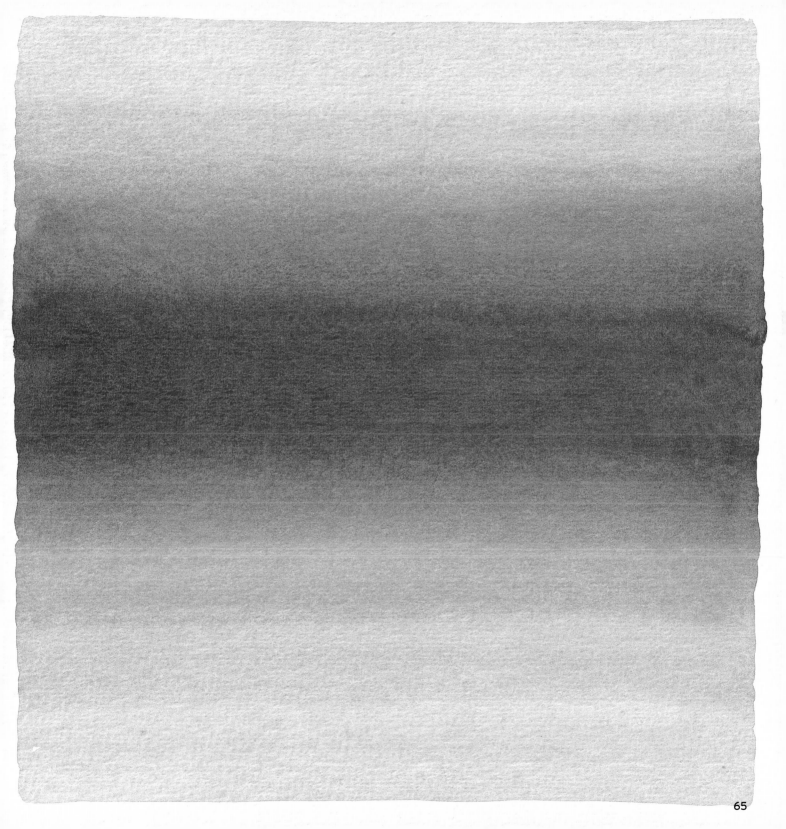

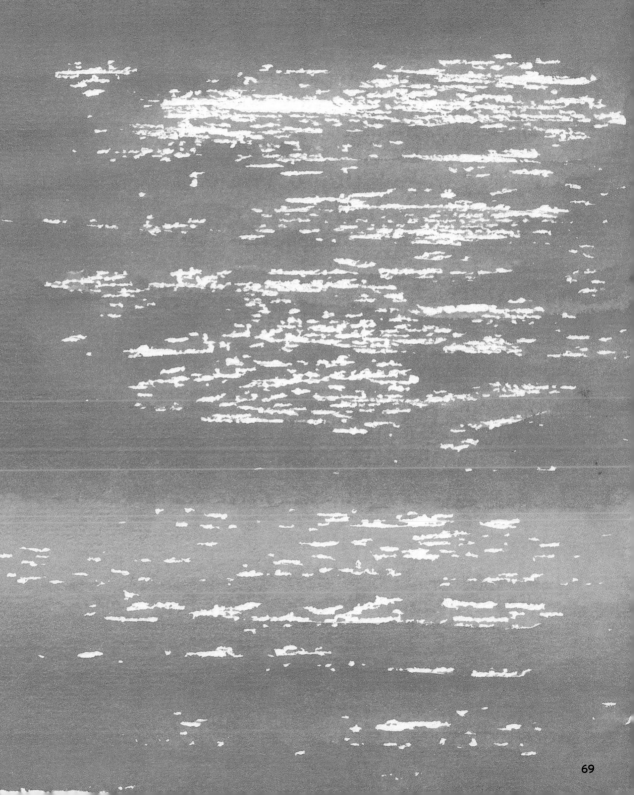

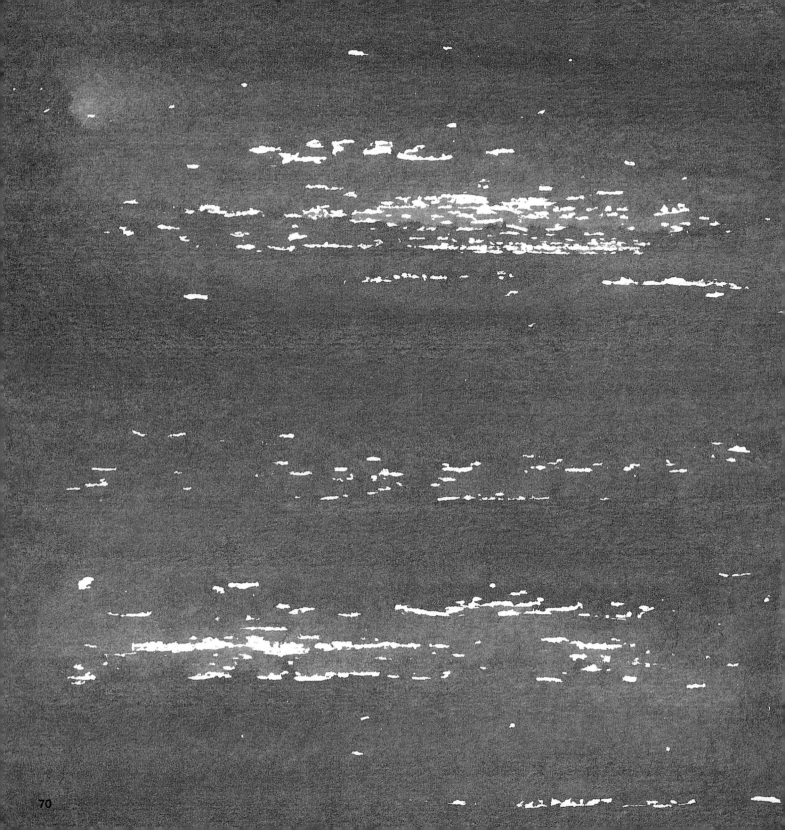

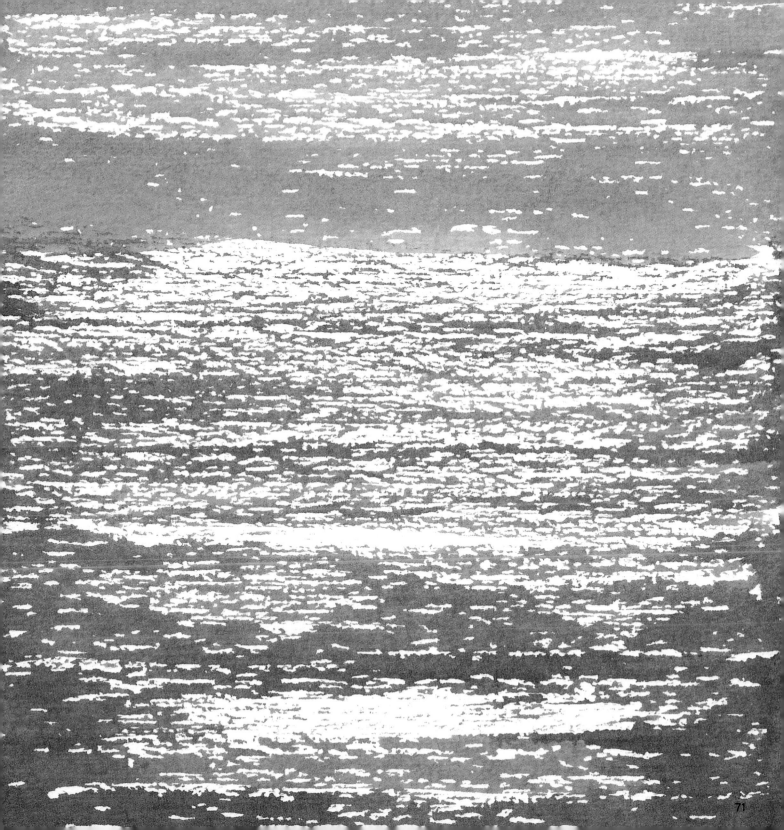

73

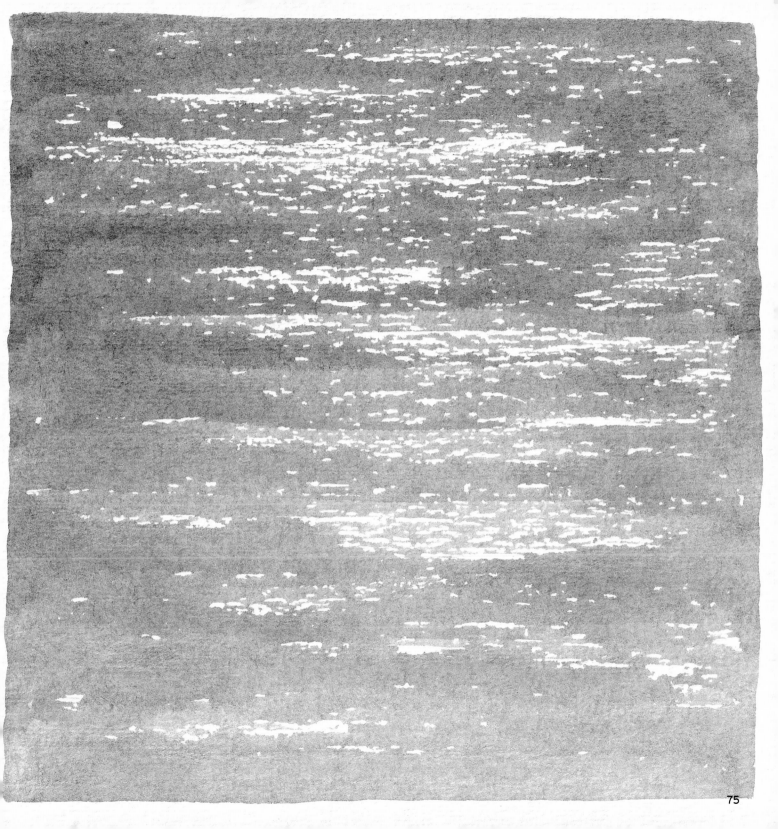

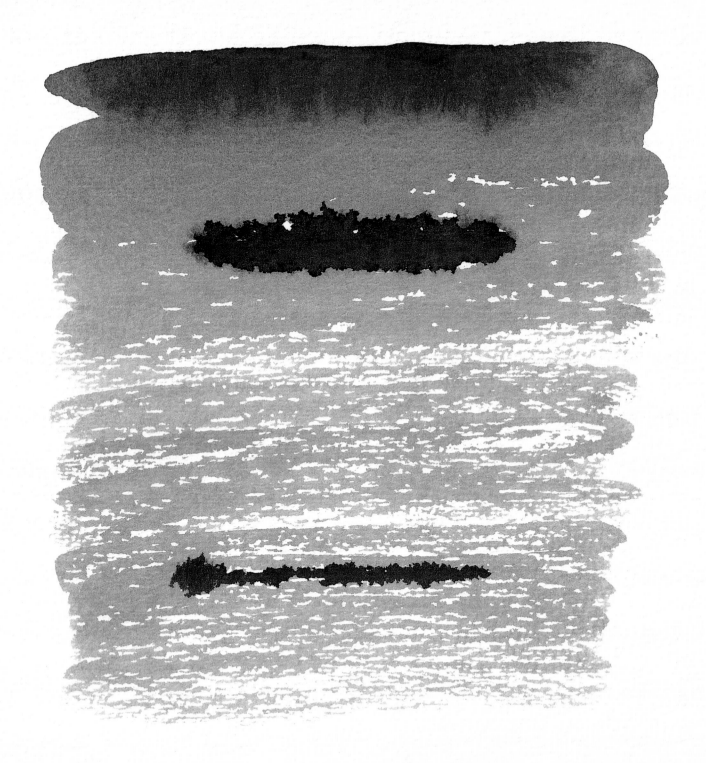

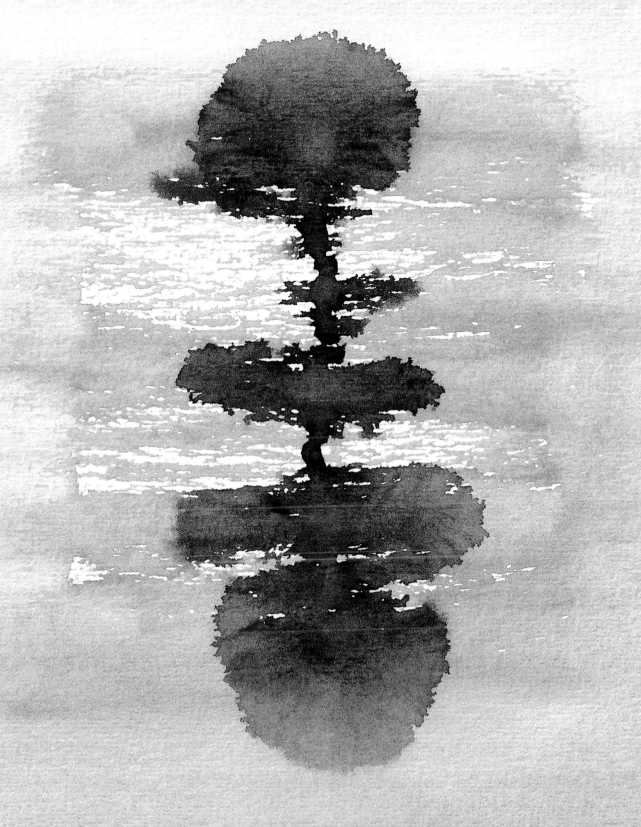

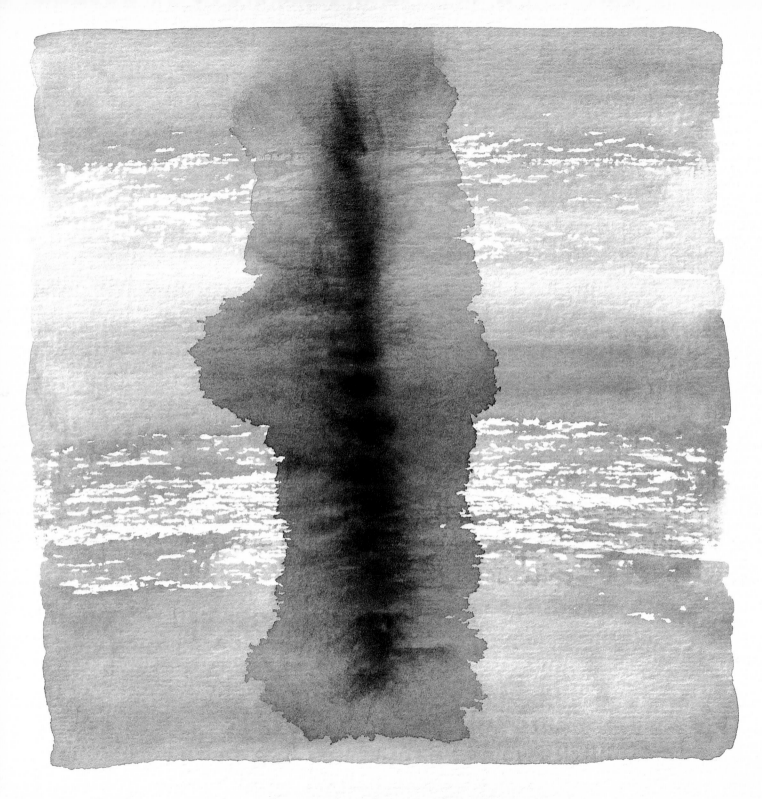

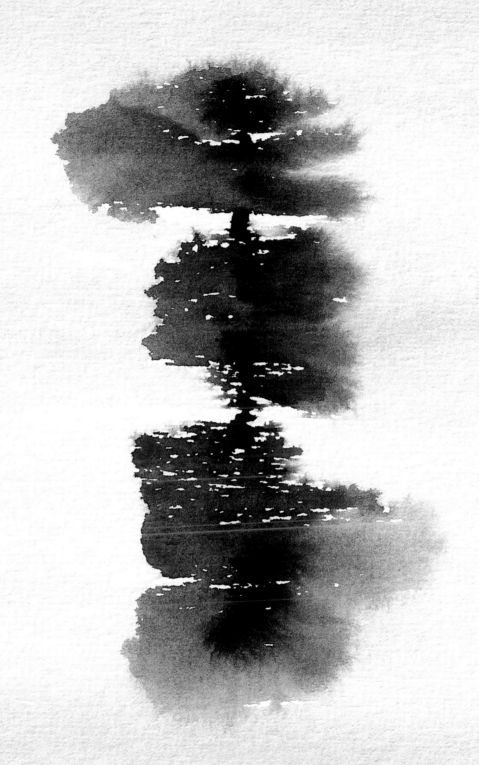

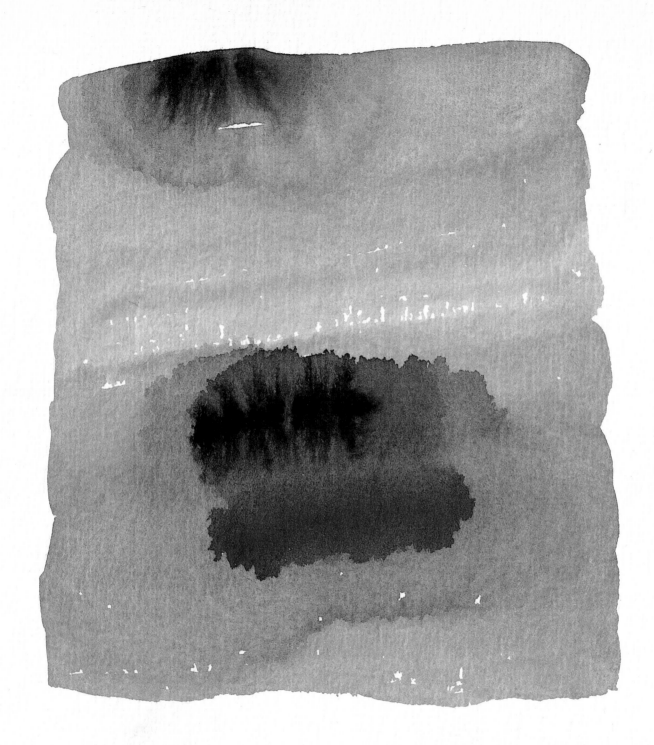

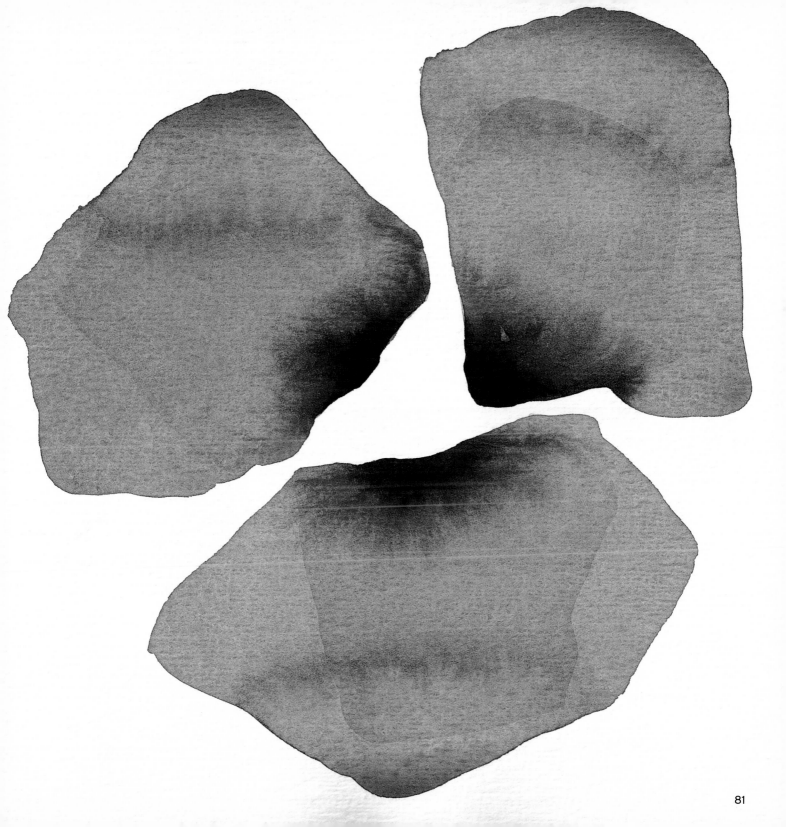

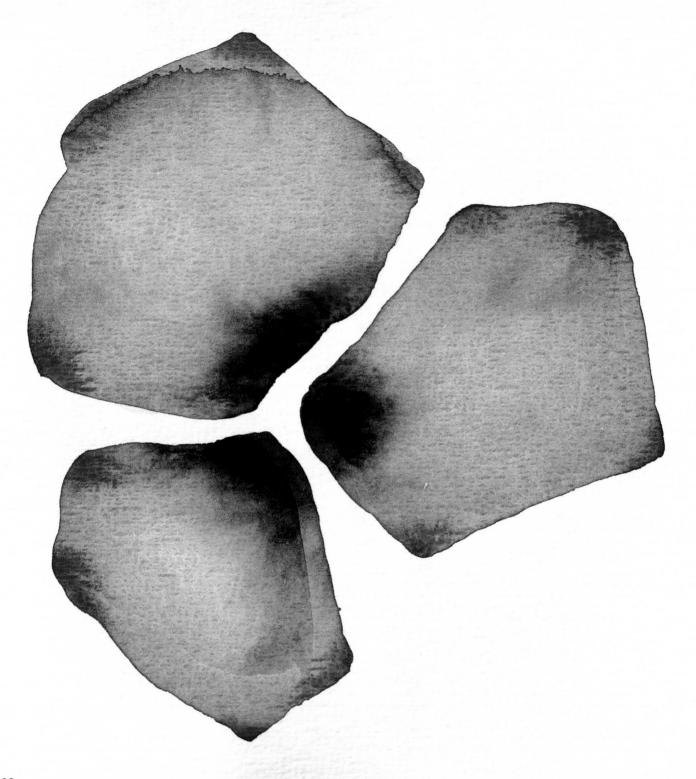

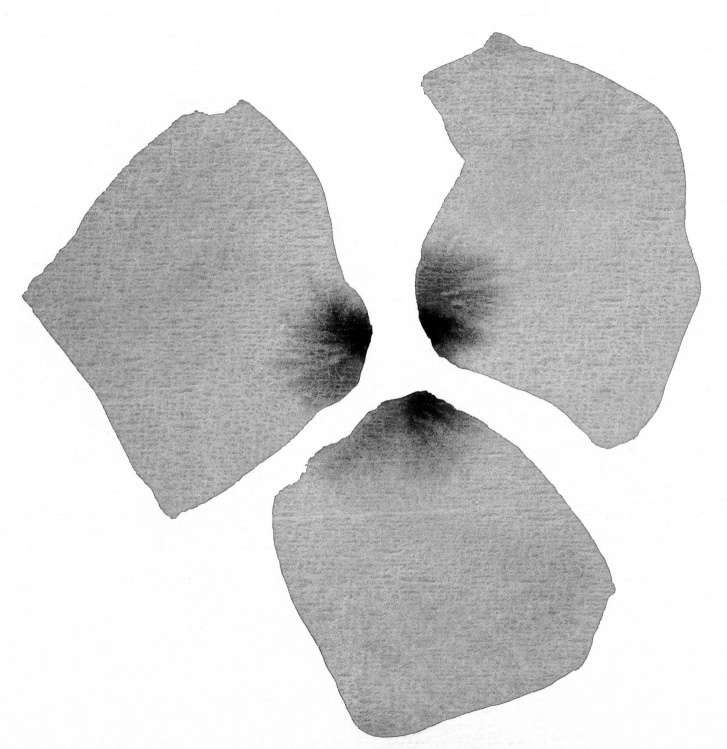

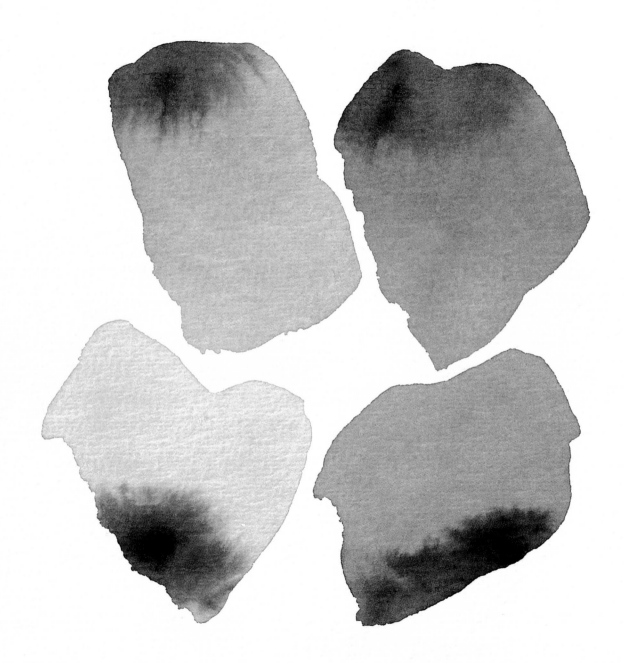

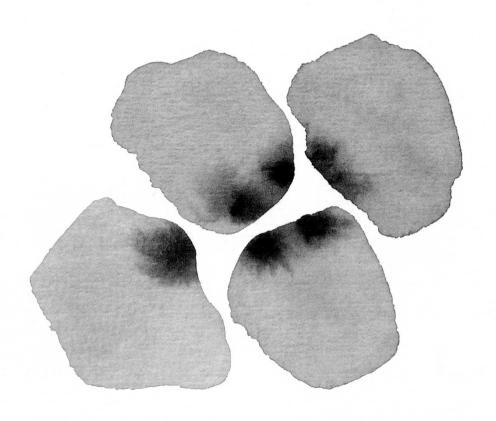

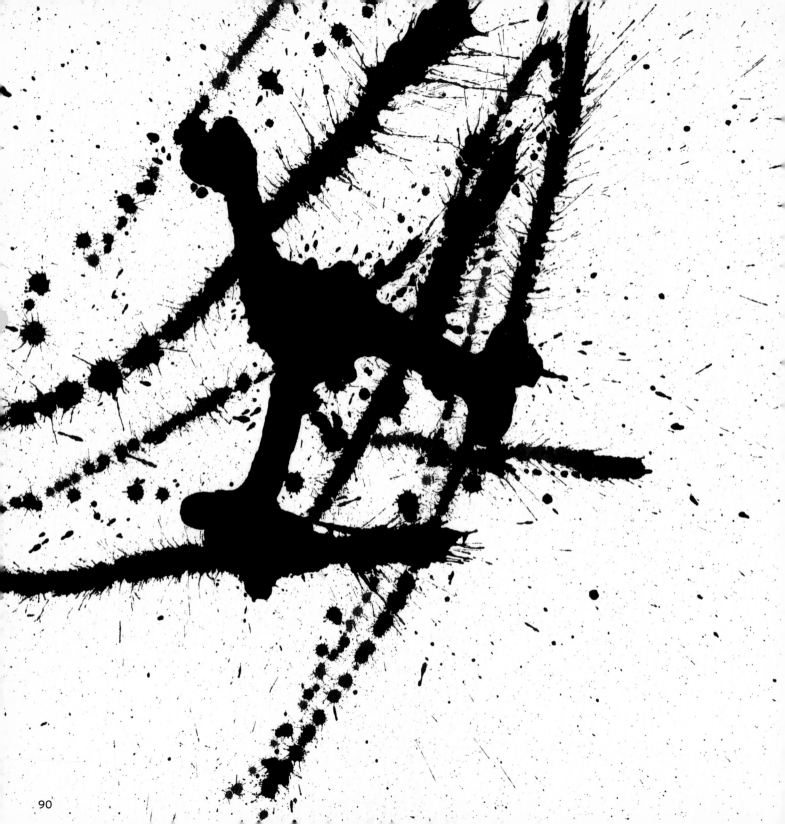

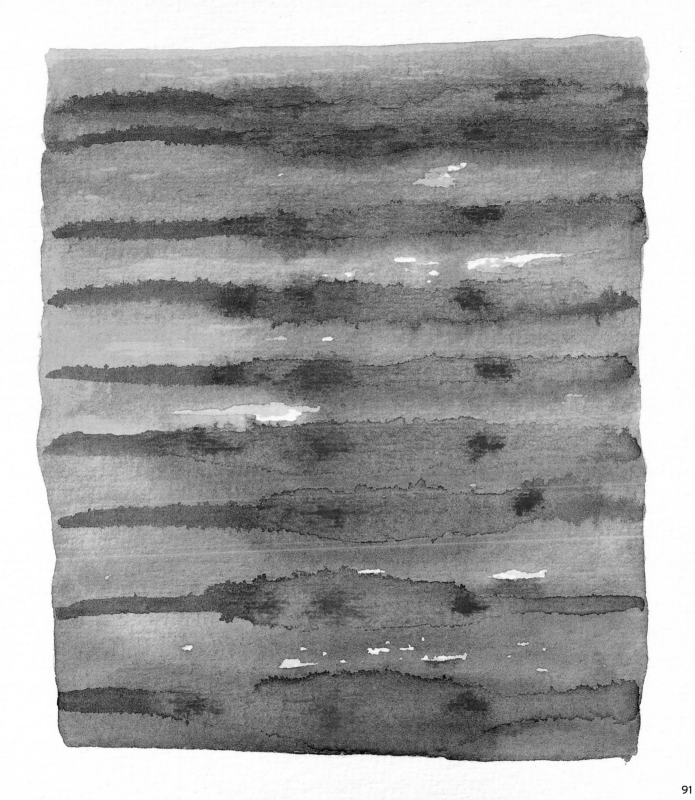

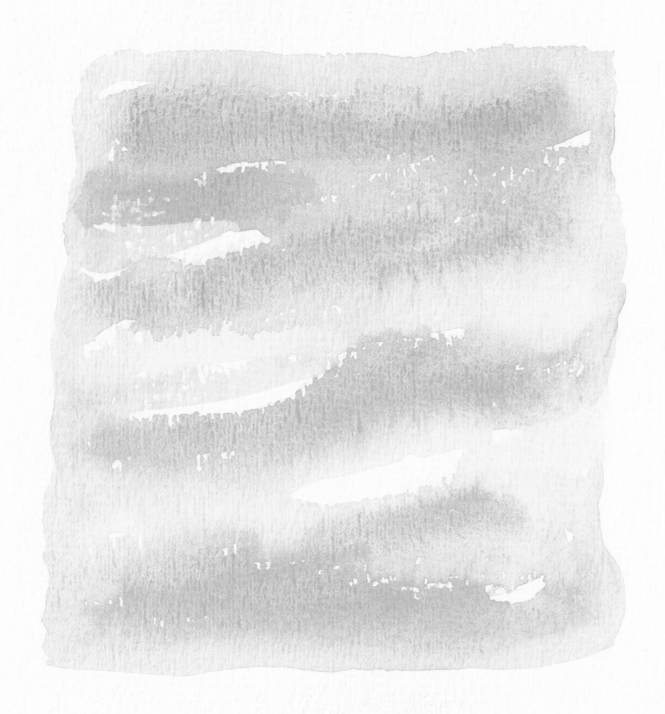

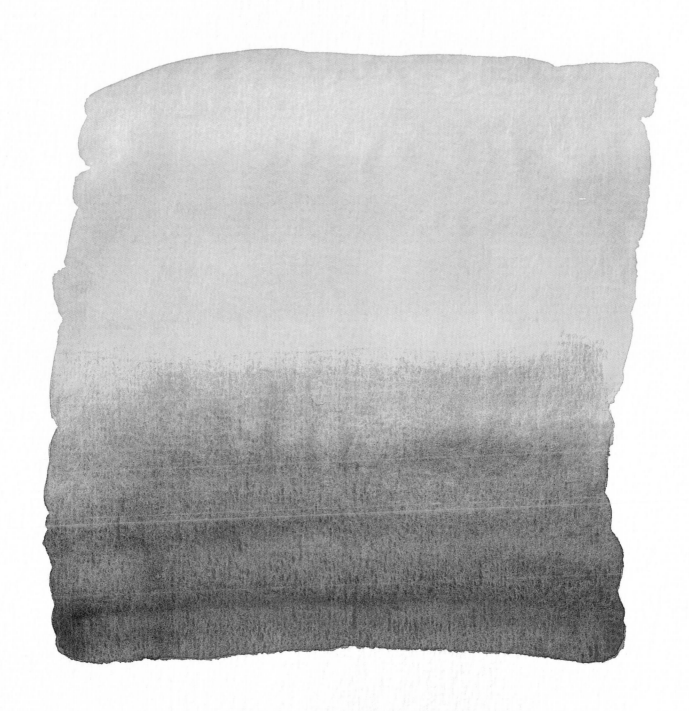

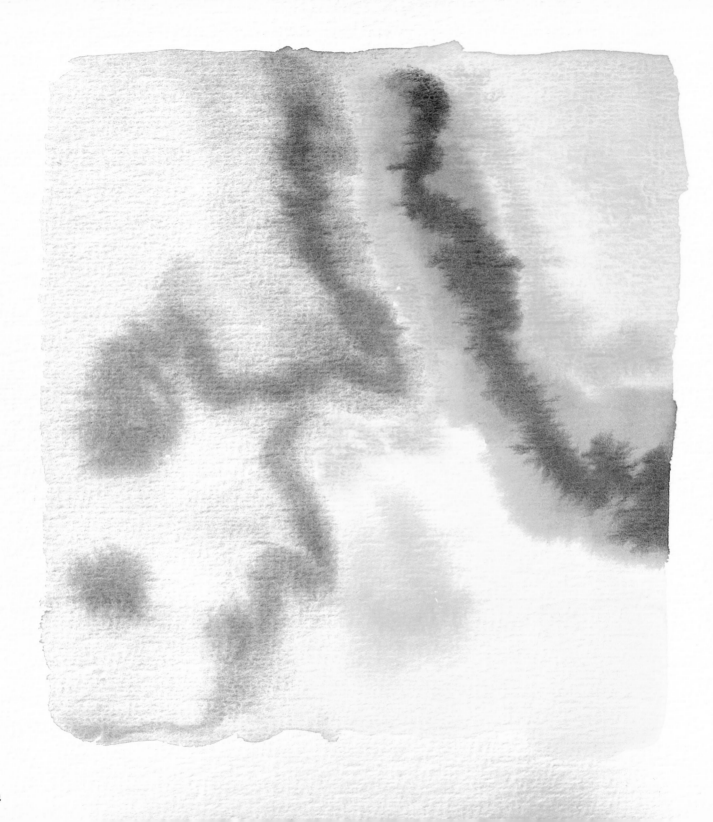

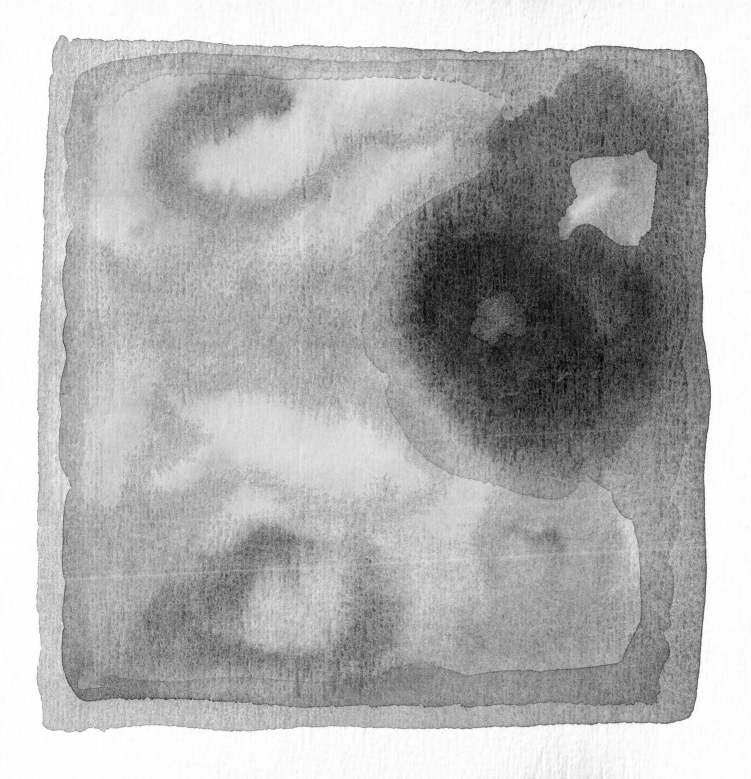

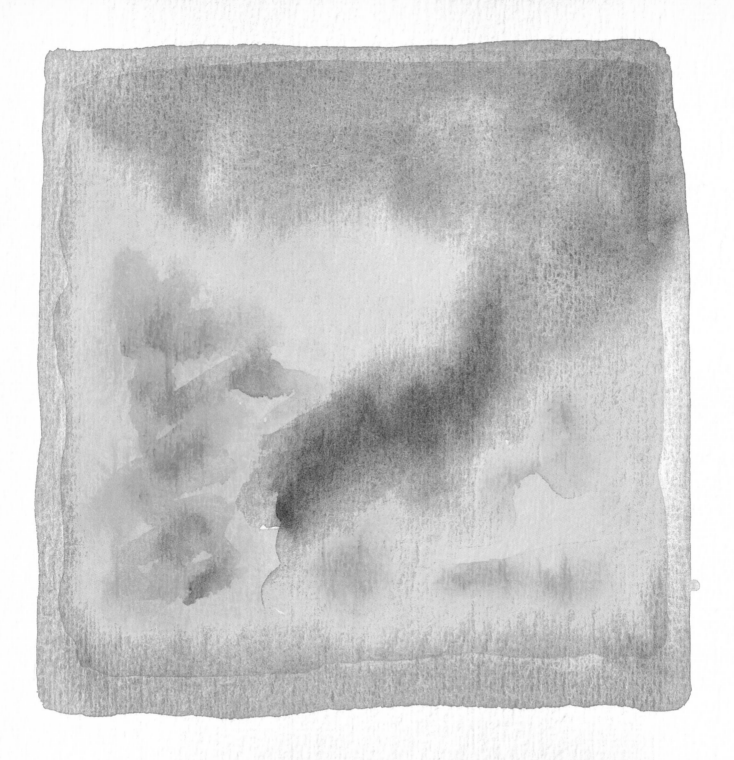

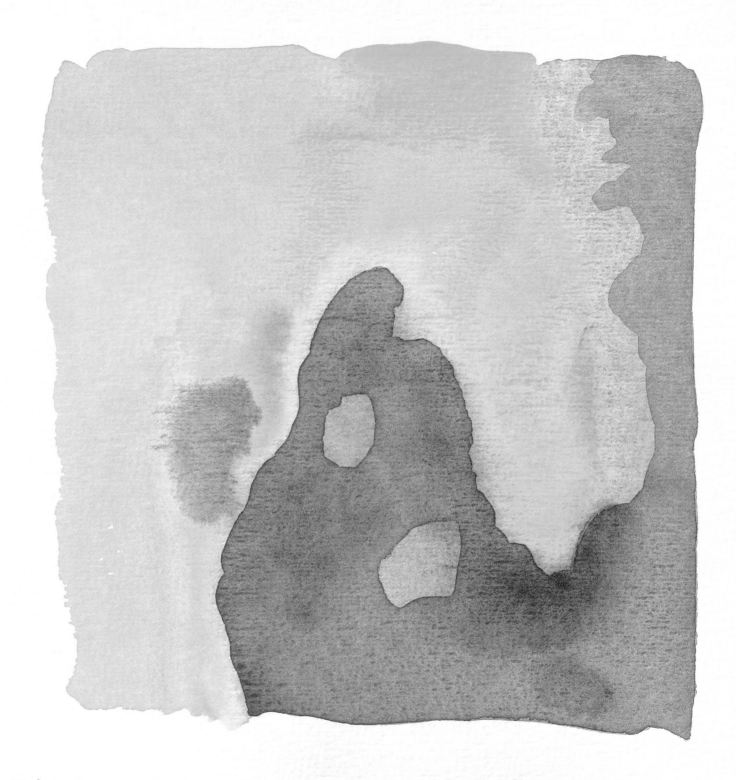

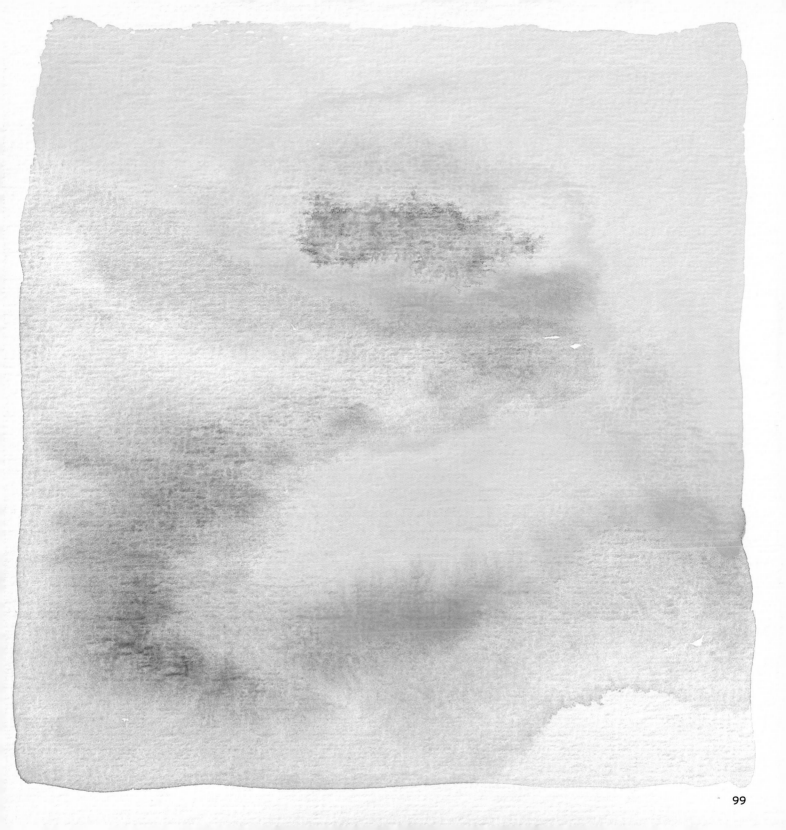

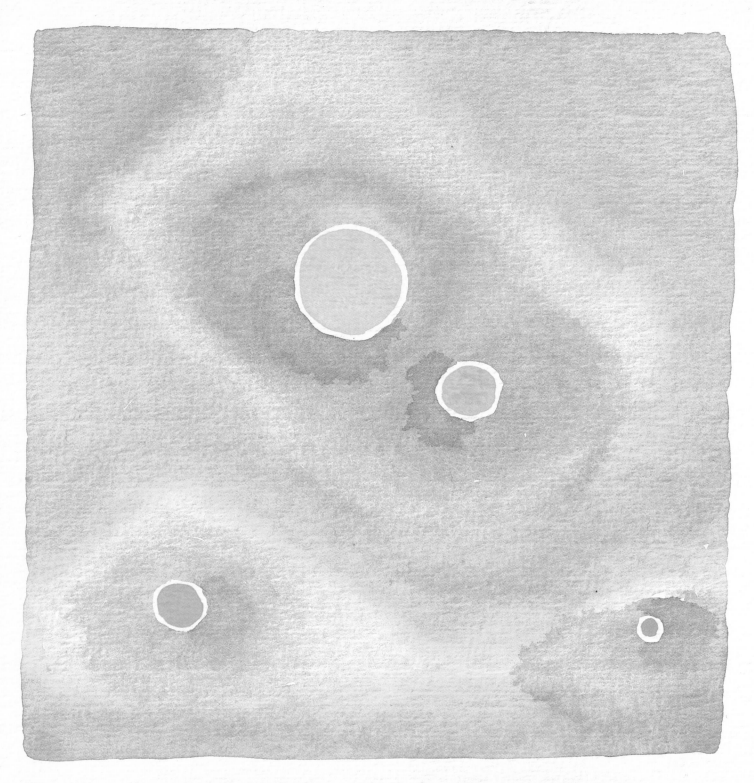

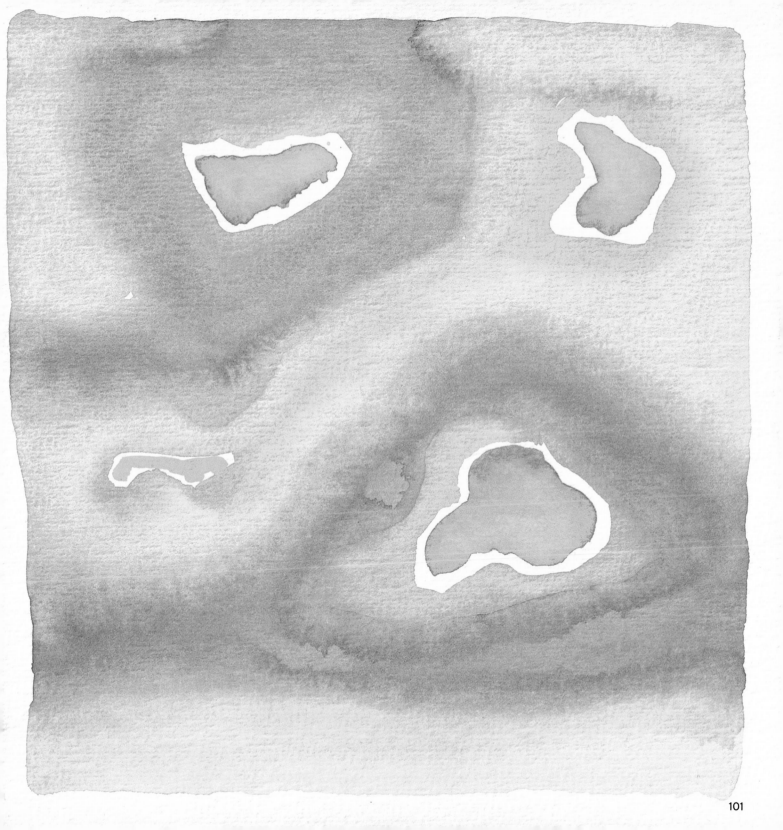

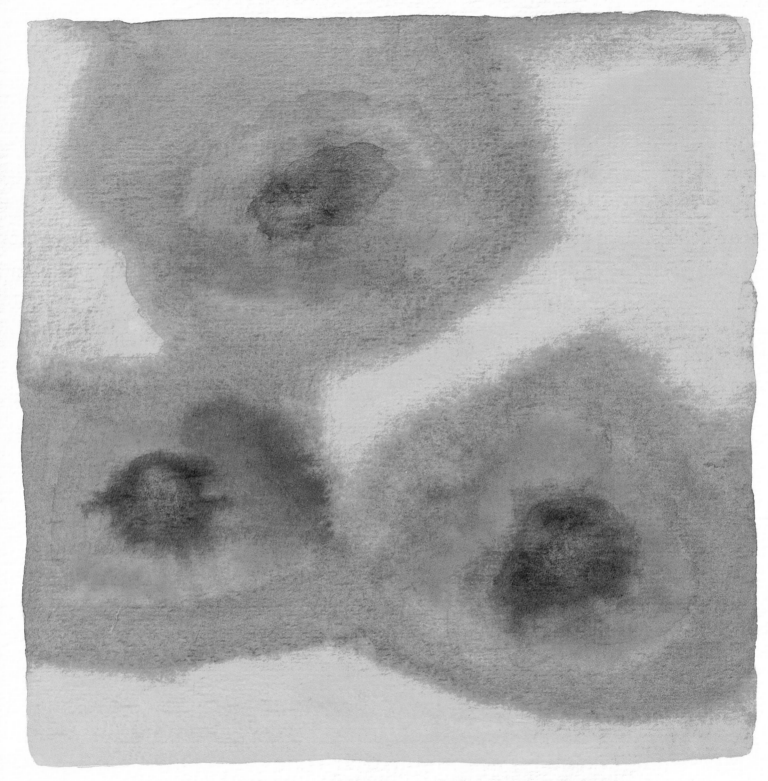

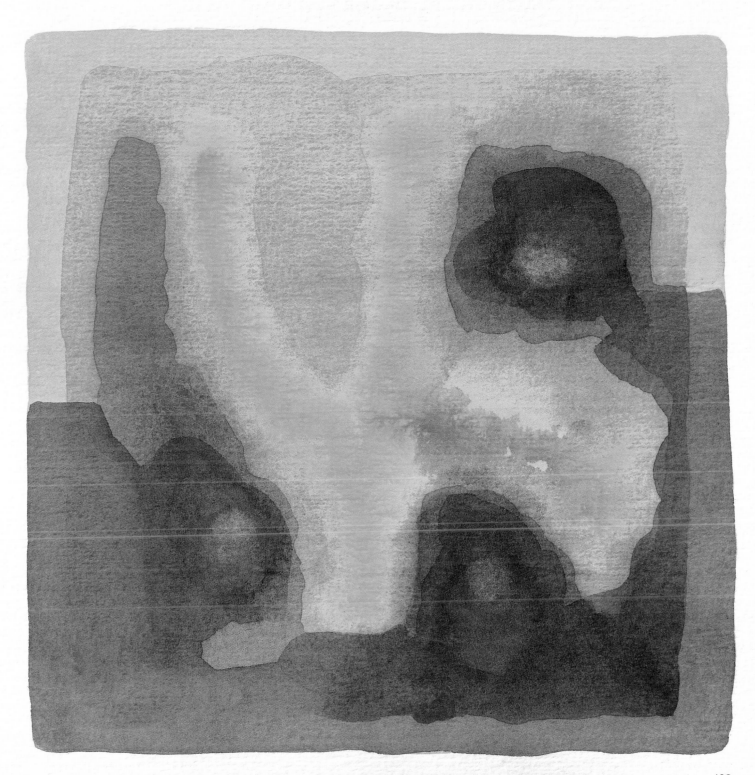

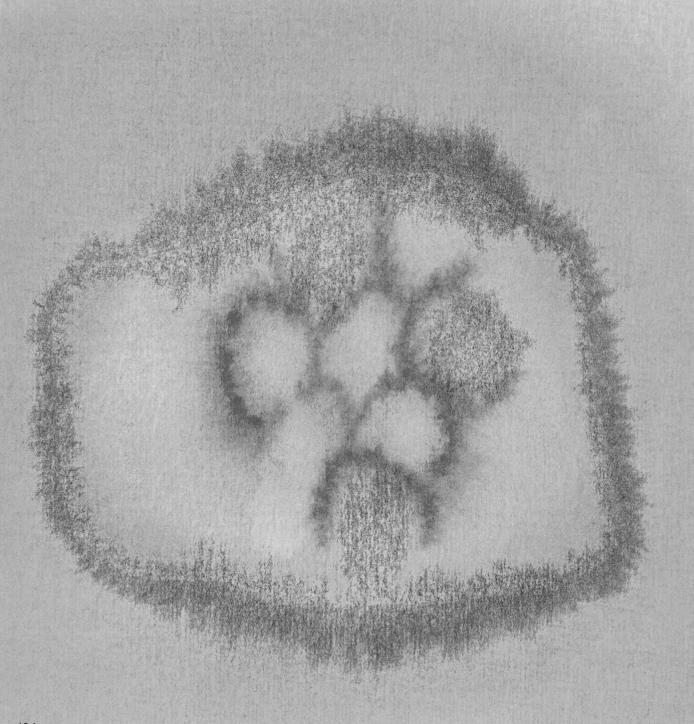

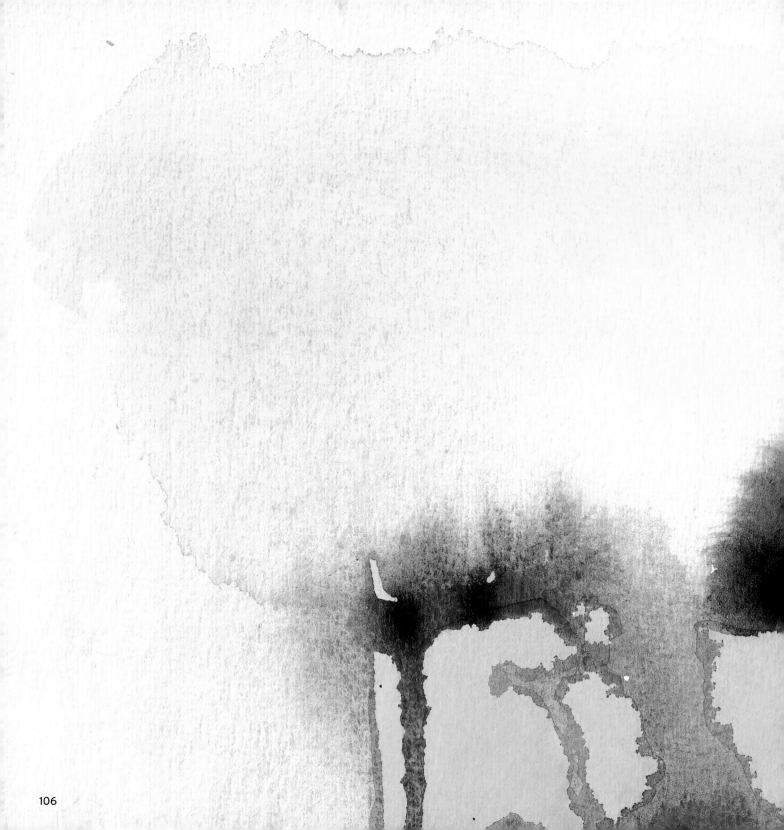

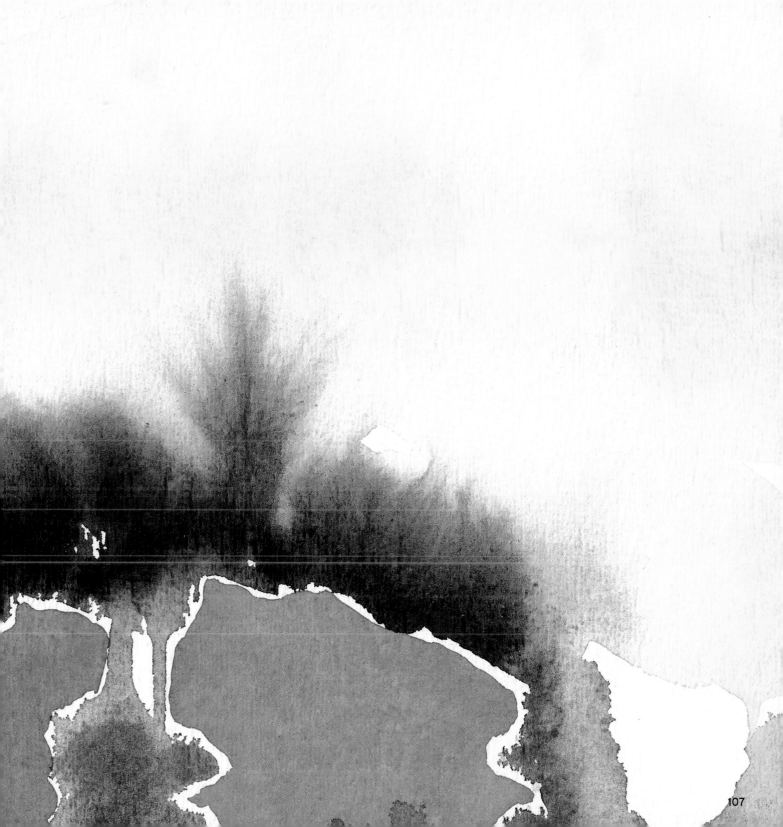

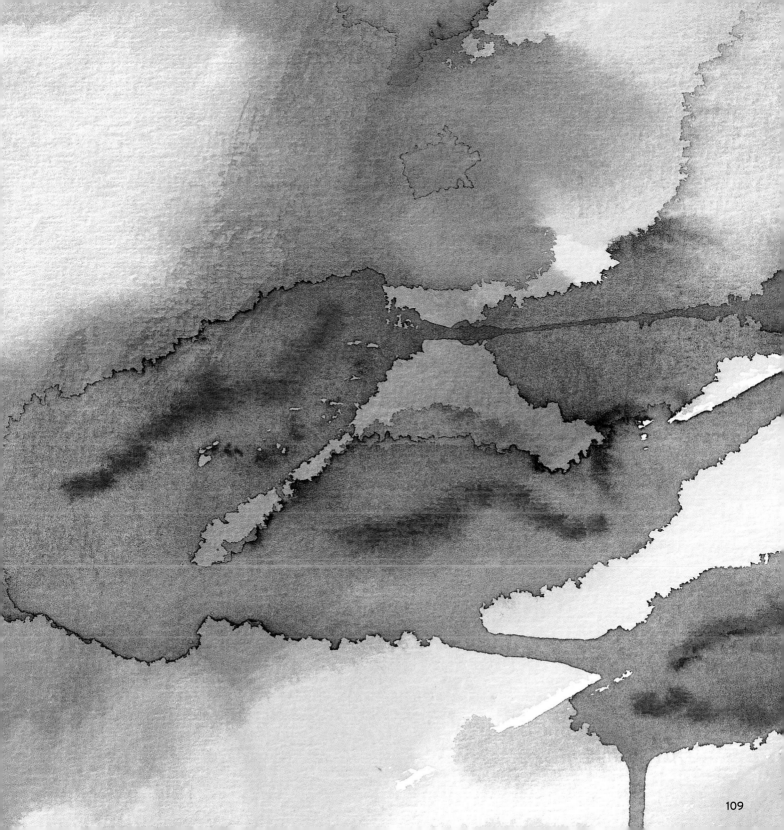

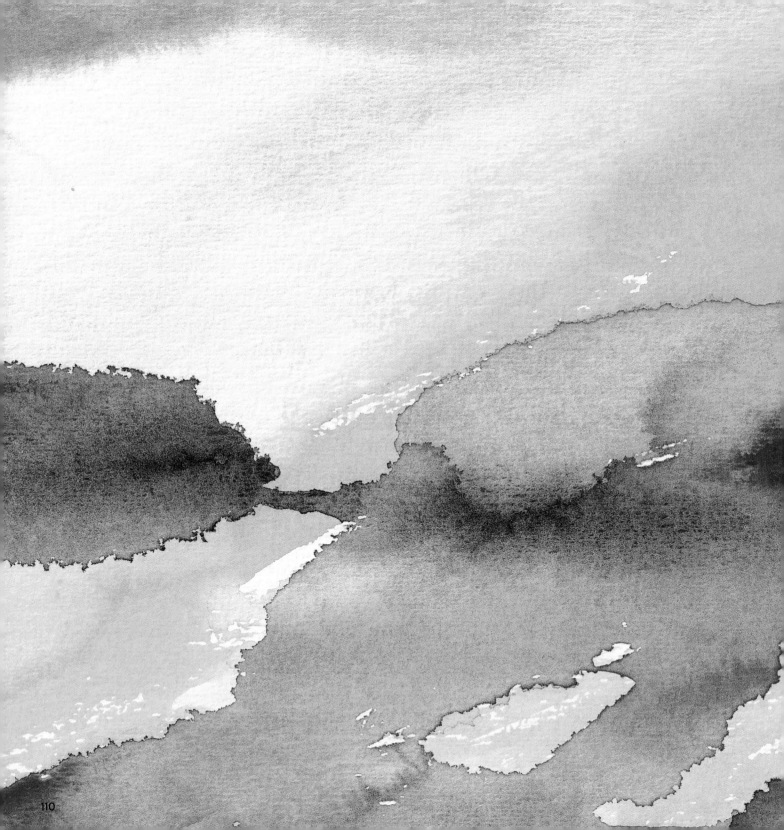

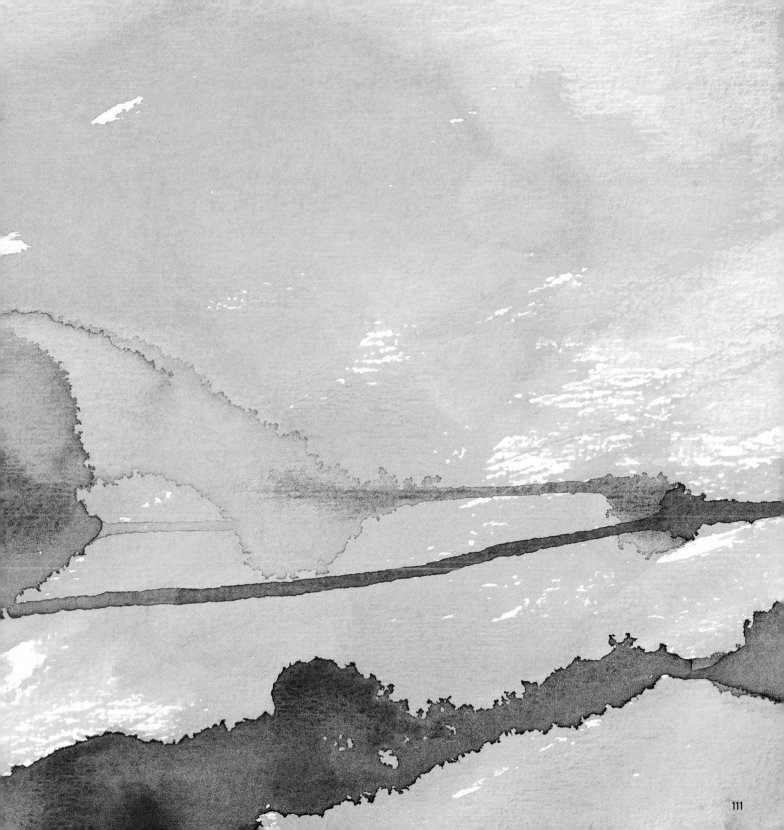

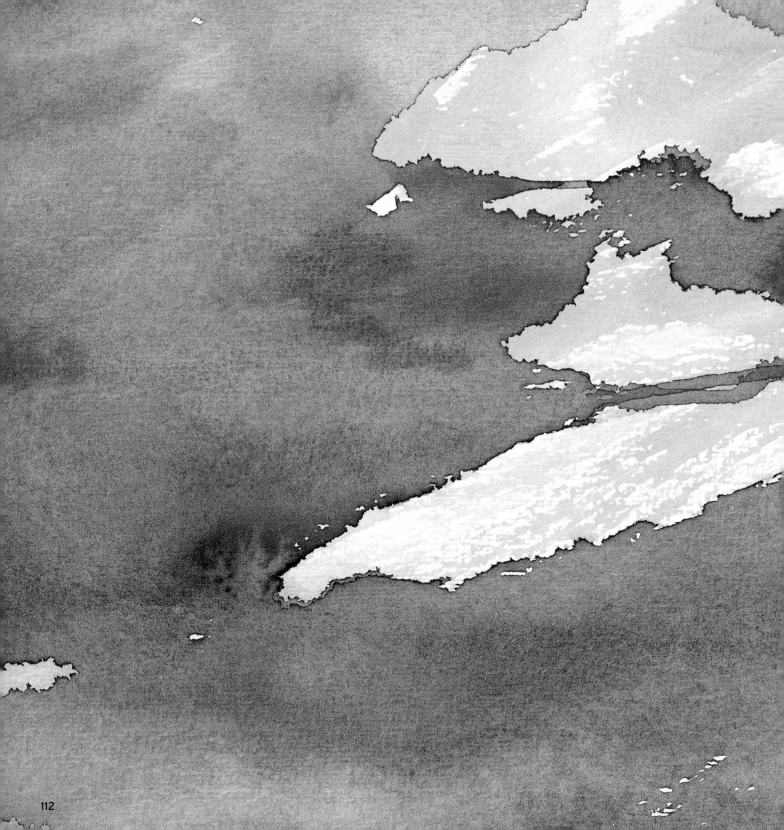

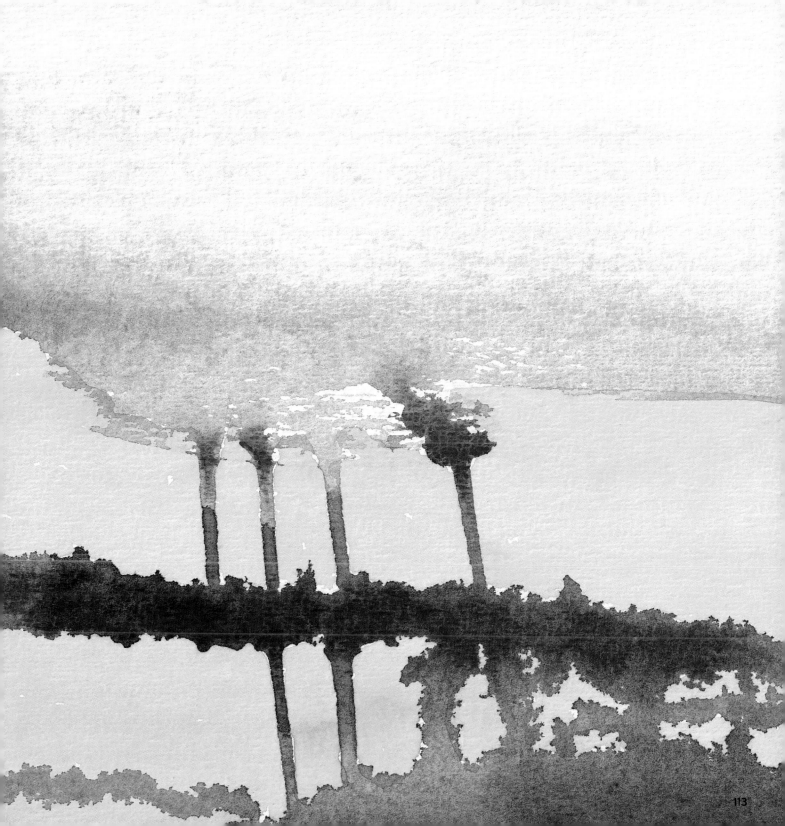

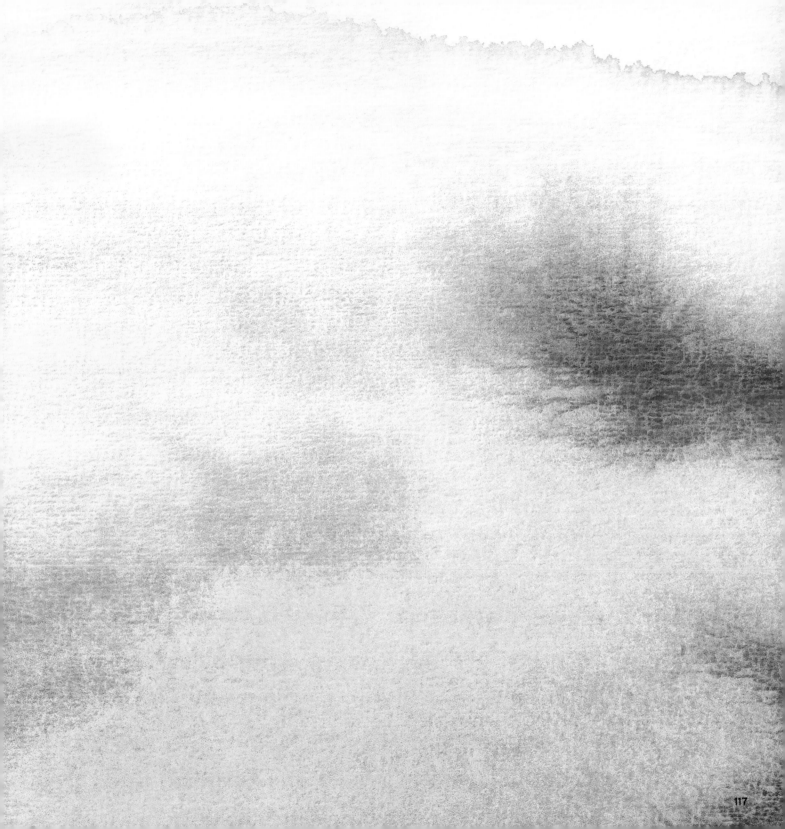

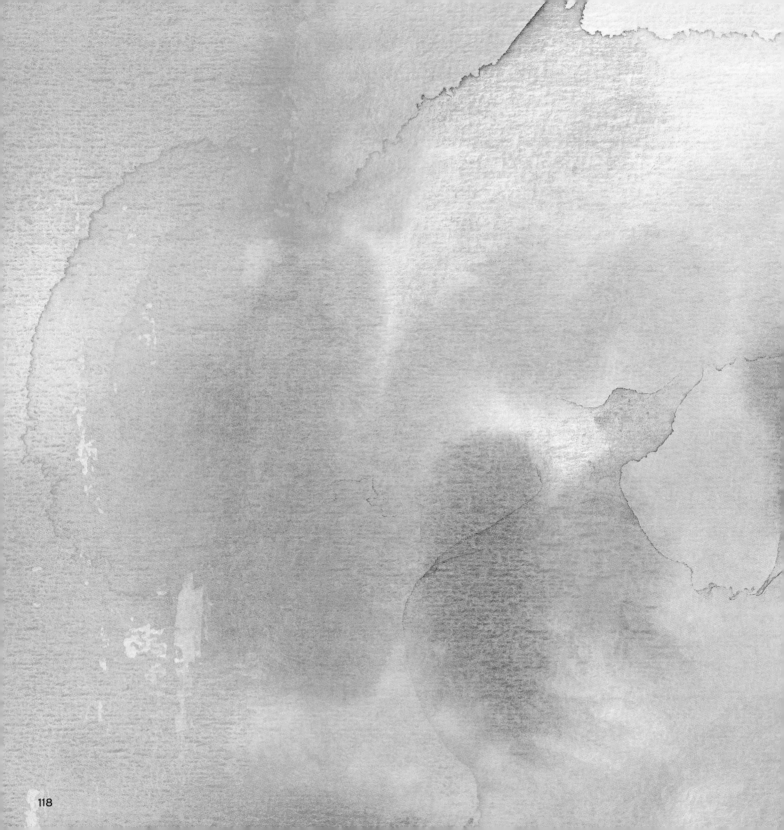

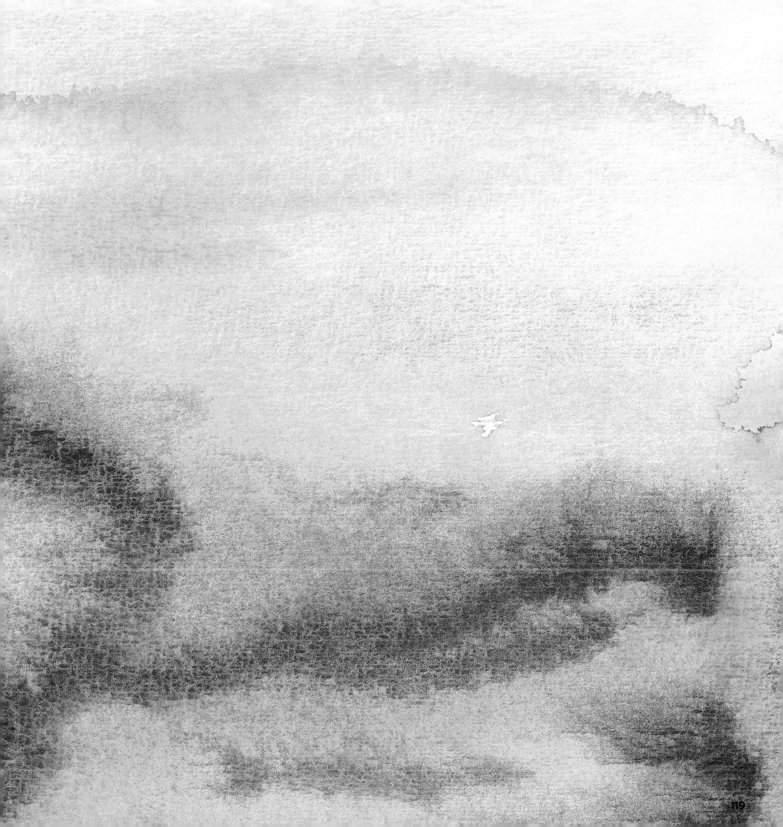

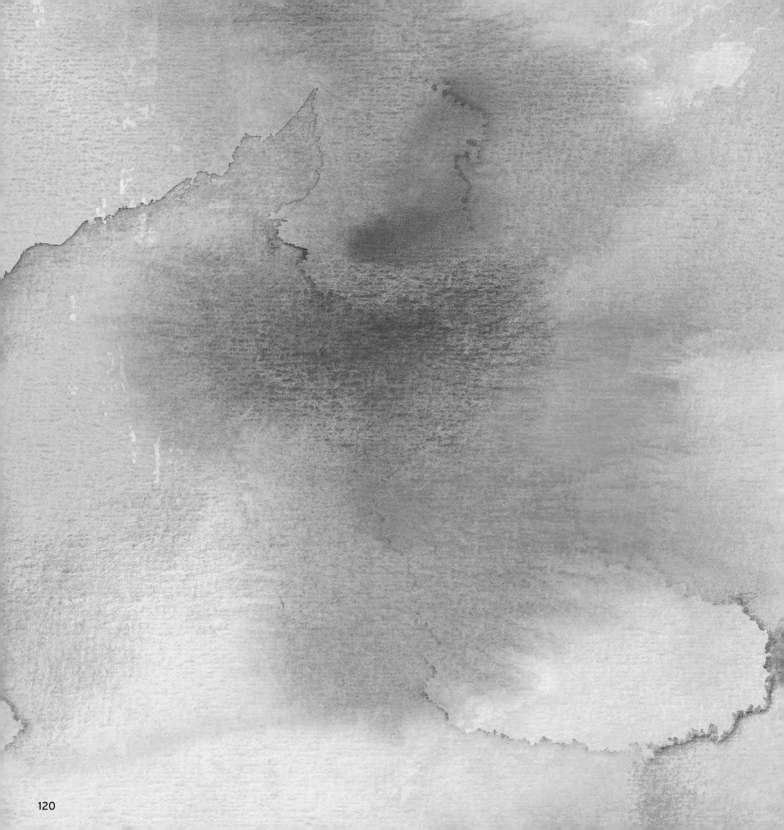

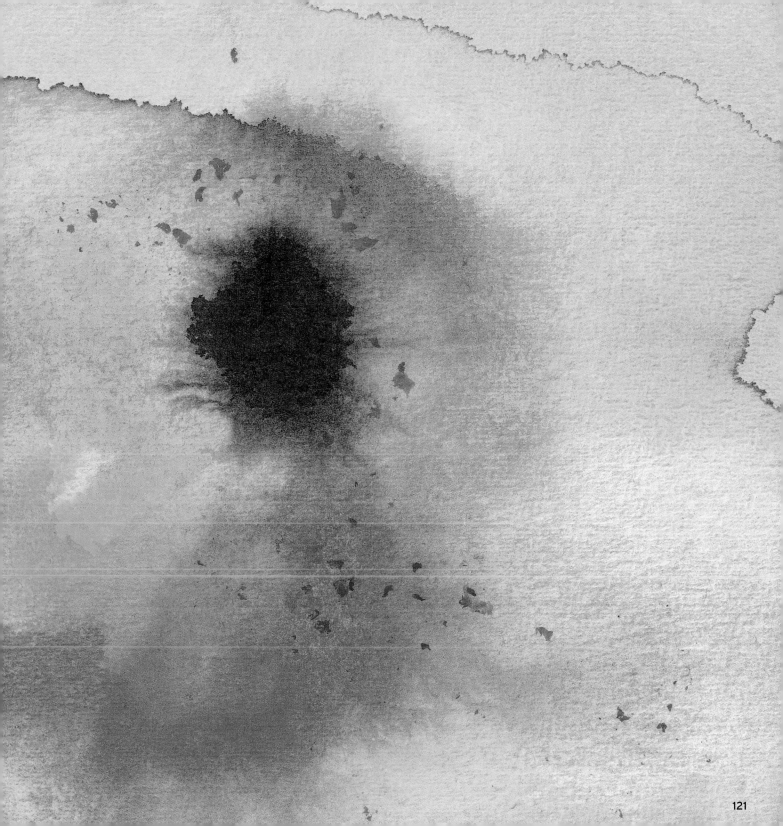

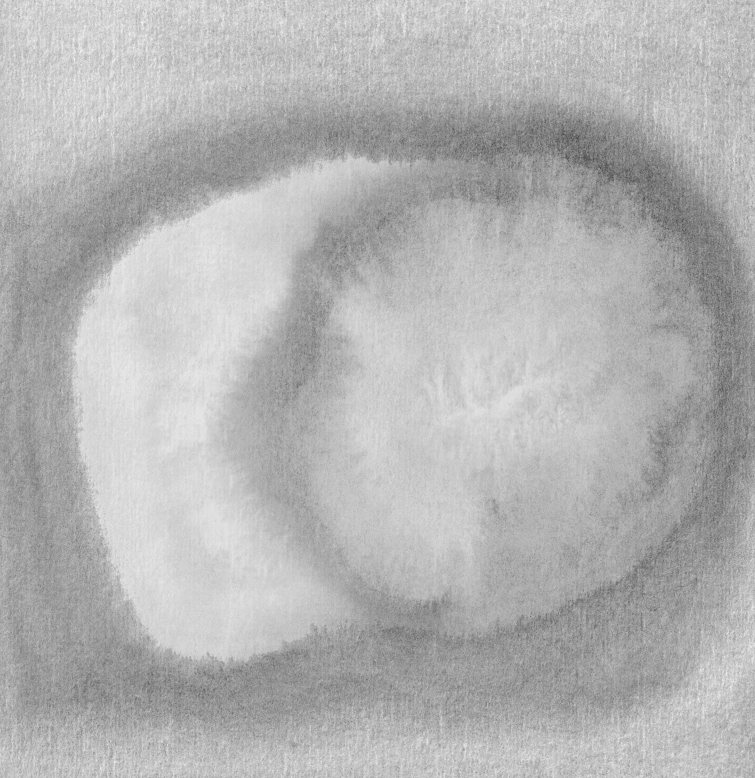

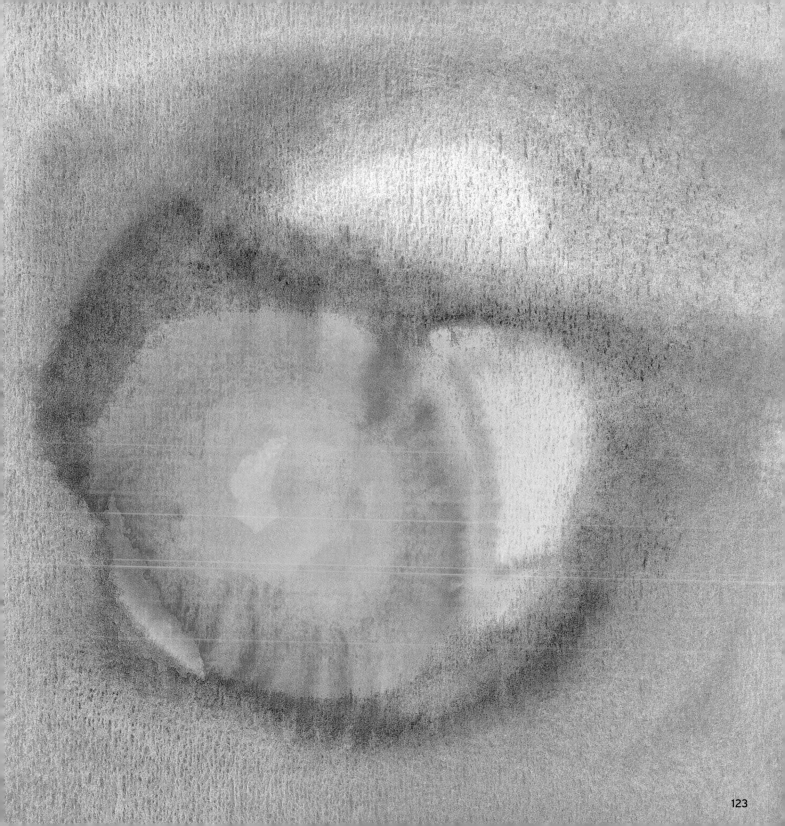

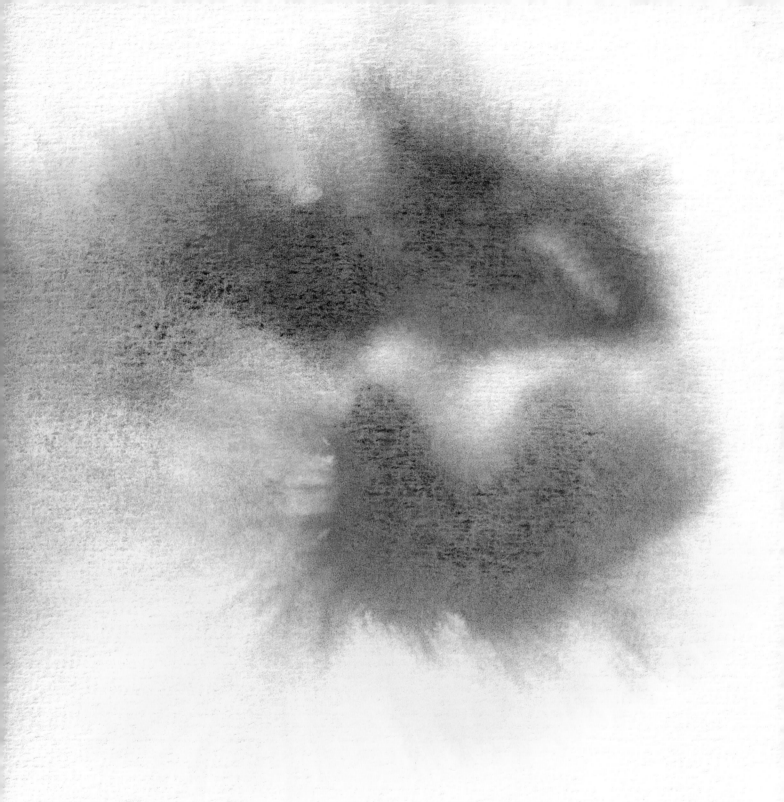

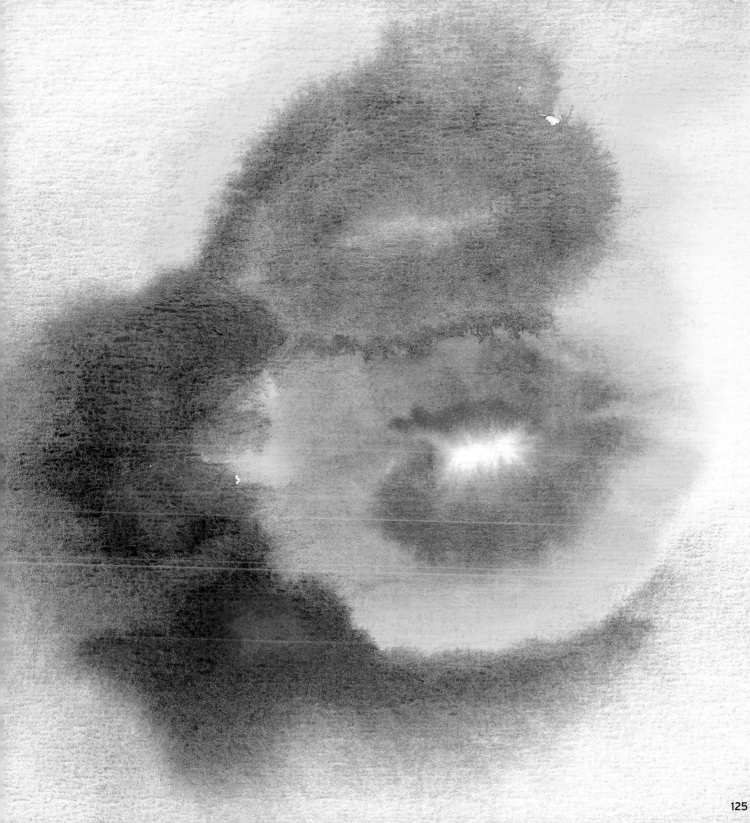

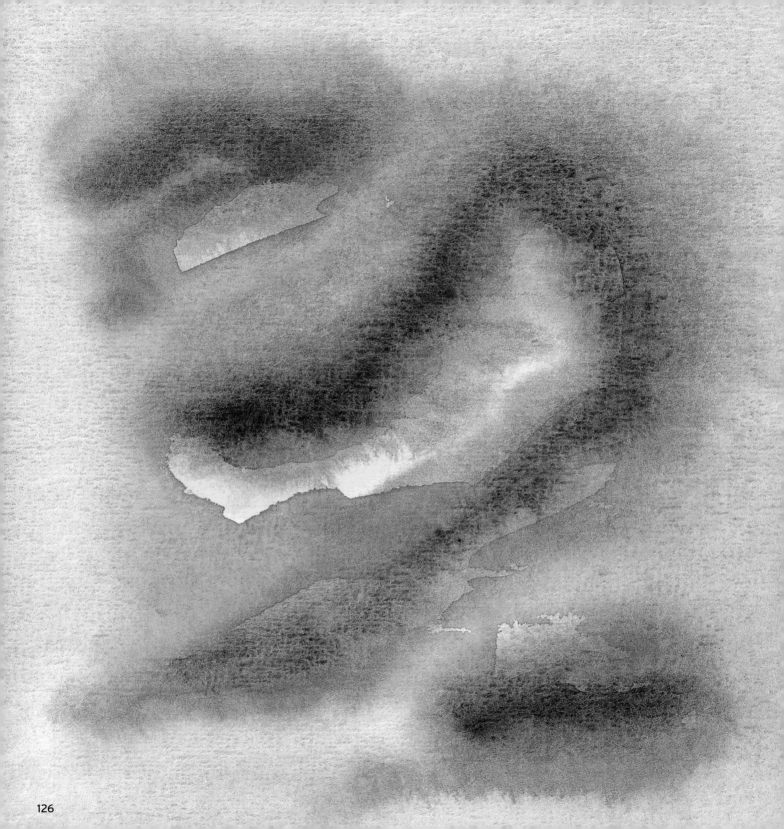

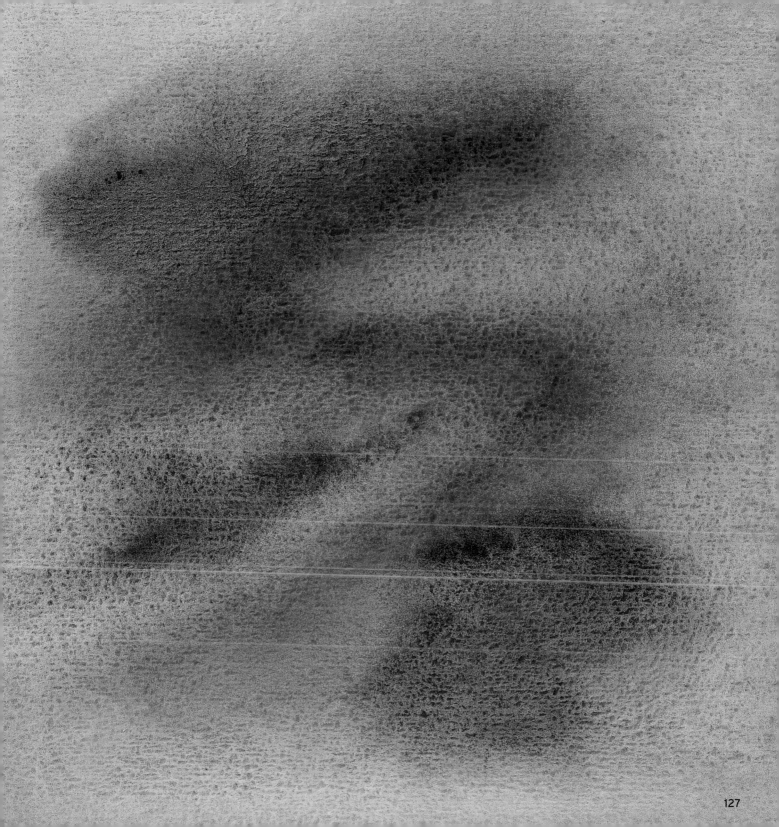

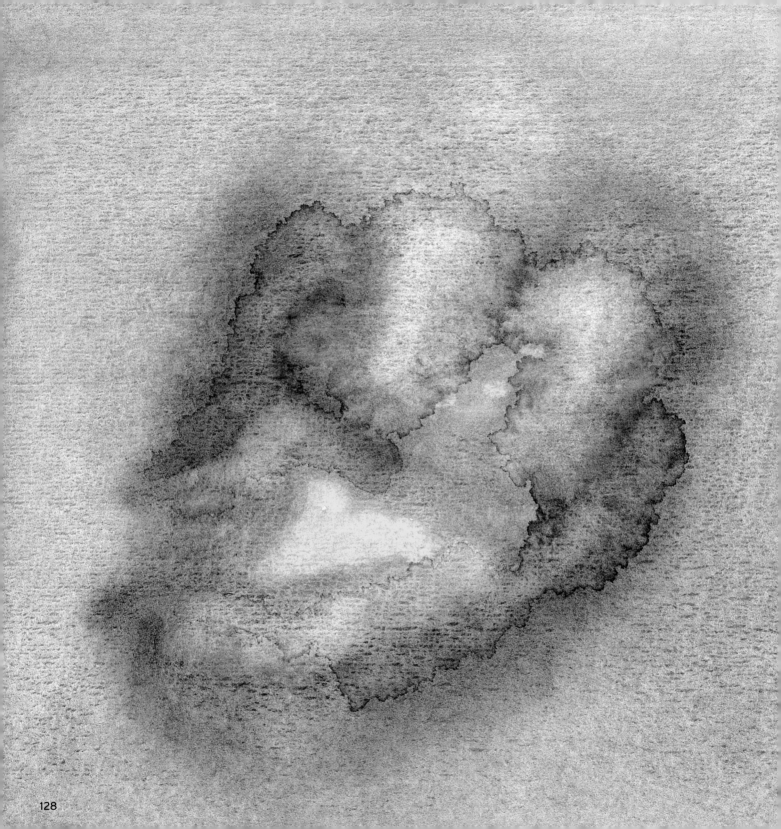

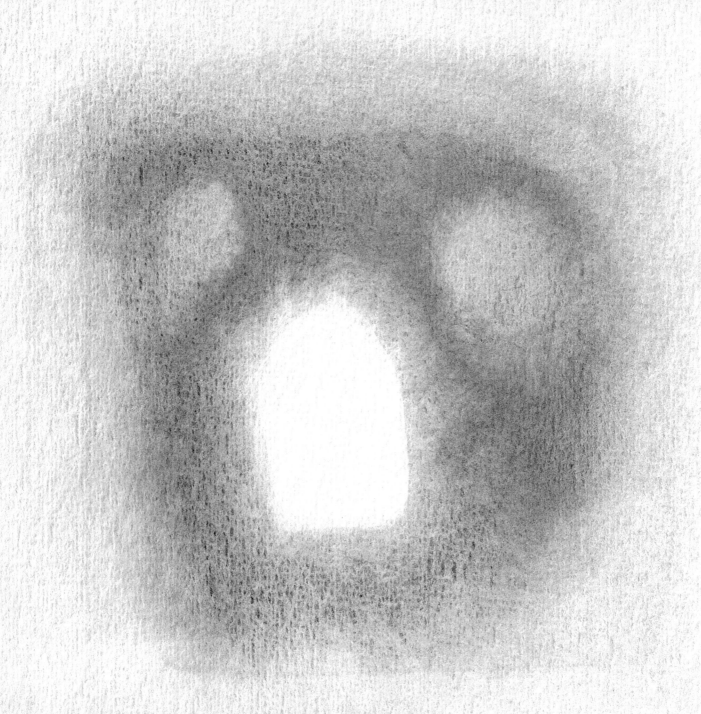

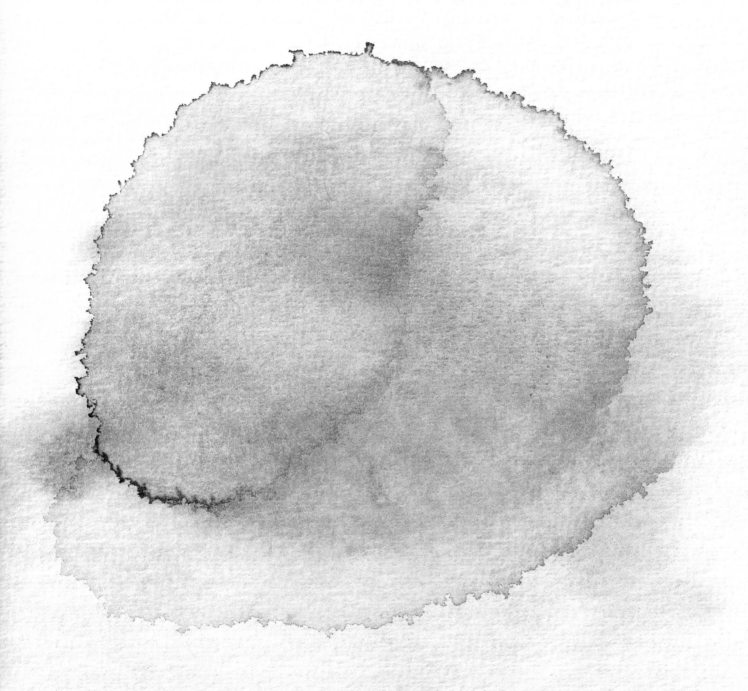

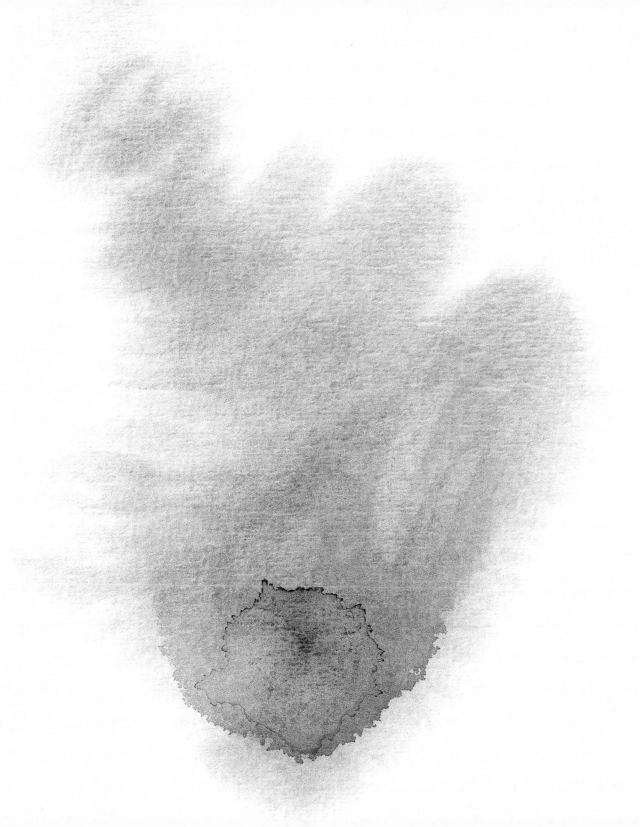

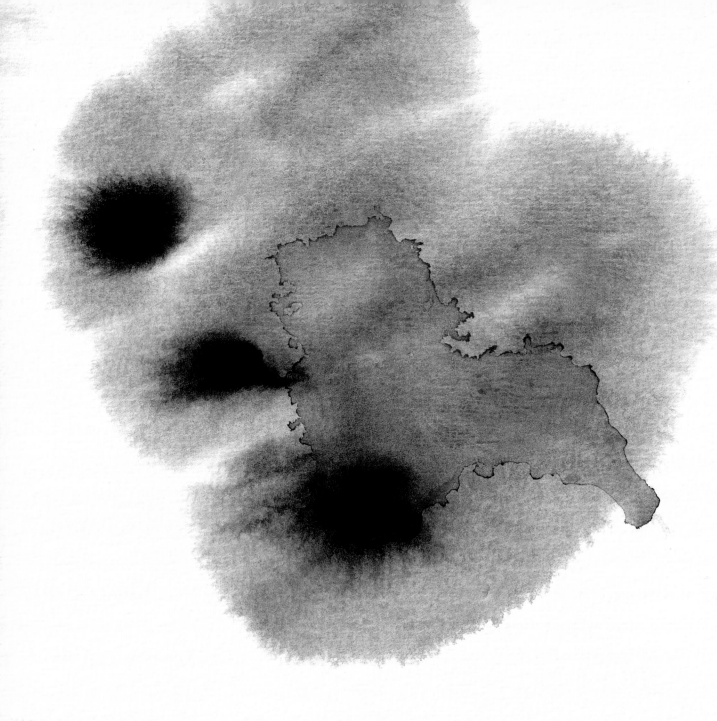

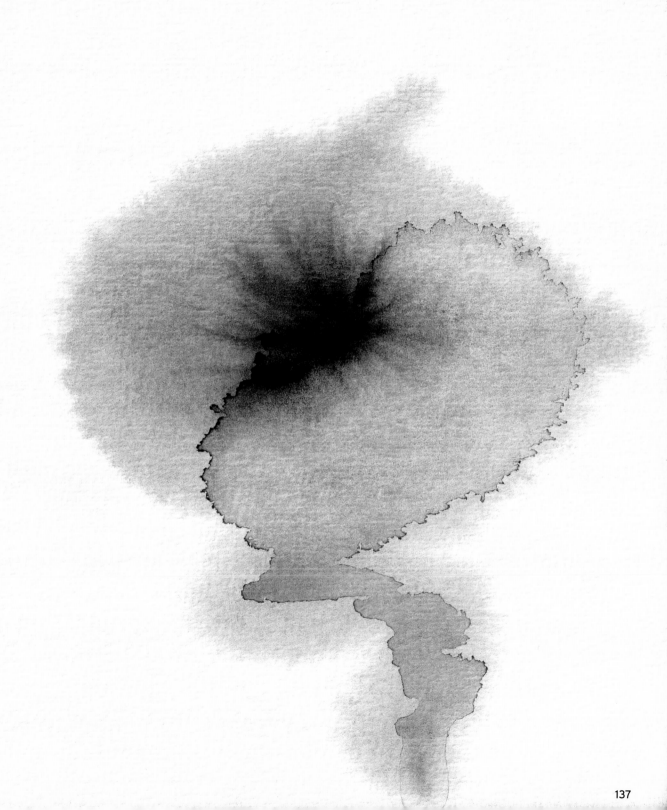

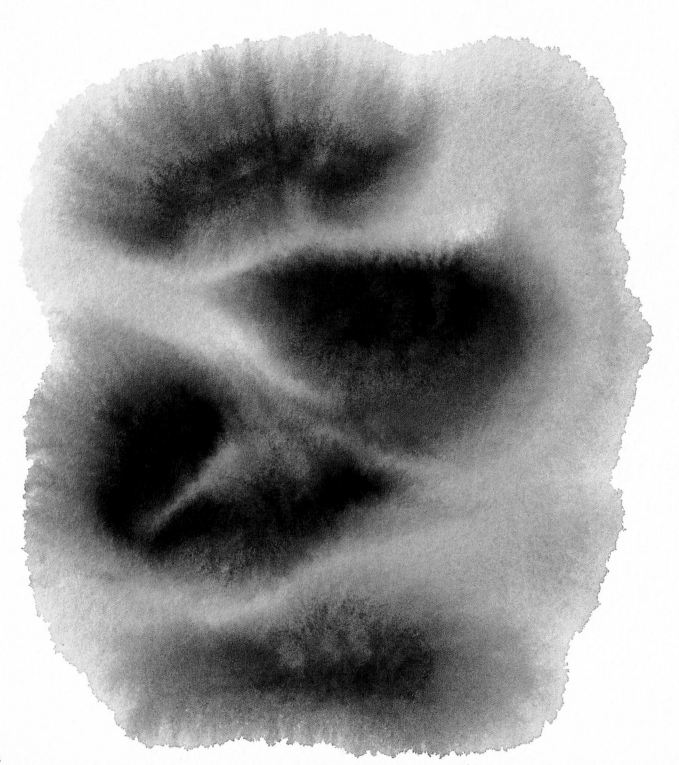